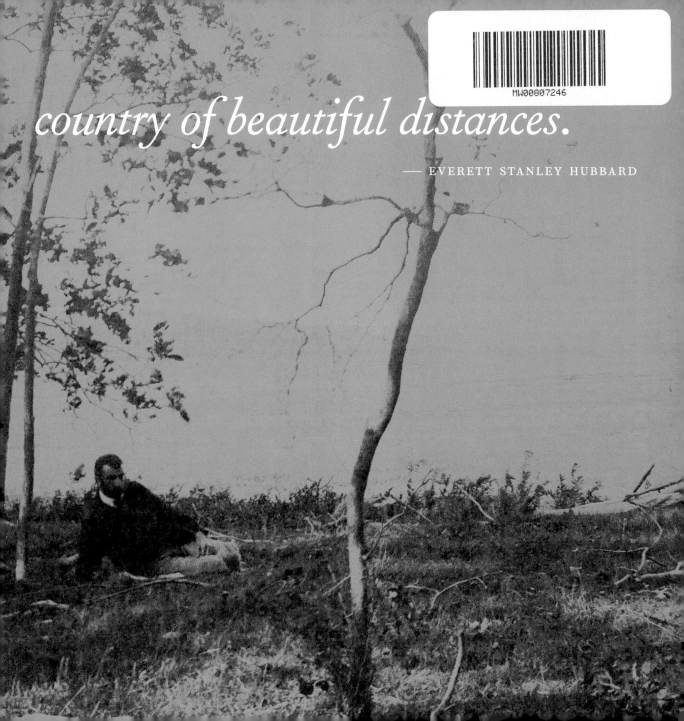

country of beautiful distances.

—— EVERETT STANLEY HUBBARD

Ipswich Days

ADDISON GALLERY OF AMERICAN ART | Phillips Academy, Andover, Massachusetts

Distributed by YALE UNIVERSITY PRESS | New Haven and London

Ipswich Days

ARTHUR WESLEY DOW AND HIS HOMETOWN

TREVOR FAIRBROTHER

Ipswich Days: Arthur Wesley Dow and His Hometown
Guest curated by Trevor Fairbrother

EXHIBITION DATES
September 22, 2007–January 6, 2008

This publication is generously funded by Mary and
Keith Kauppila.

PUBLISHED BY
Addison Gallery of American Art, Phillips Academy,
Andover, Massachusetts

Addison Gallery of American Art
Phillips Academy
180 Main Street
Andover, Massachusetts 01810
www.addisongallery.org

DISTRIBUTED BY
Yale University Press
302 Temple Street
P.O. Box 209040
New Haven, Connecticut 06520
www.yalebooks.com

LIBRARY OF CONGRESS CATALOGING-IN-PUBLICATION DATA
Fairbrother, Trevor J.
 Ipswich days : Arthur Wesley Dow and his hometown / Trevor Fairbrother.
 p. cm.
 Issued in connection with an exhibition held Sept. 22, 2007–Jan. 6, 2008,
Addison Gallery of American Art, Andover, Massachusetts.
 Includes bibliographical references.
 ISBN: 978-0-300-13291-5
 1. Dow, Arthur W. (Arthur Wesley), 1857–1922—Exhibitions. 2. Ipswich
(Mass.)—Pictorial works—Exhibitions. 3. Landscape photography—
Exhibitions. I. Addison Gallery of American Art. II. Title.

F74.I6F25 2007
779´.997445092–dc22 2007021972

Unless otherwise noted, all images illustrated are by
Arthur Wesley Dow (1857–1922).

All works from *Ipswich Days*, 1899, are in the collection
of John T. and Susan H. Moran.

FRONT COVER
The Cove and Old Shipyard, from *Ipswich Days*, 1899
Cyanotype
4 x 5 in. (10.2 x 12.7 cm)

BACK COVER
Untitled, from *Ipswich Days* (detail), 1899
Cyanotype
5 x 4 in. (12.7 x 10.2 cm)

INSIDE COVERS
Arthur Wesley Dow Reclining in Landscape, Ipswich
(detail), c. 1899
Platinum print, 4 5/8 x 7 5/8 in. (11.8 x 19.4 cm)
Addison Gallery of American Art,
partial gift of George and Barbara Wright and
partial purchase as the gift of R. Crosby Kemper through
the R. Crosby Kemper Foundation

FRONT ENDSHEET
Unidentified photographer, *Ipswich from Heartbreak Hill*
(detail), illustration in *The Celebration of the Two
Hundred and Fiftieth Anniversary of the Incorporation of
the Town of Ipswich, Massachusetts, August 16, 1884*
(Boston: Little, Brown, and Company, 1884)

BACK ENDSHEET
Ipswich Marshes from Bayberry Hill (detail), c. 1900
Hand-tipped gelatin silver print
3 x 3 in. (7.62 x 7.62 cm)
Addison Gallery of American Art,
partial gift of George and Barbara Wright and
partial purchase as the gift of R. Crosby Kemper through
the R. Crosby Kemper Foundation

DESIGNER Bill Anton | Service Station
EDITOR Joseph N. Newland | Q.E.D.
PRINTER Lotus Printing, Inc. | China

CONTENTS

FOREWORD BRIAN T. ALLEN *The Mary Stripp and R. Crosby Kemper Director*

SUSAN C. FAXON *Associate Director and Curator of Art before 1950*

For seventy-five years the Addison Gallery of American Art, on the campus of Phillips Academy in Andover, Massachusetts, has served as a cultural and artistic resource for the citizens of Essex County and beyond. Through its extraordinary collection, innovative exhibitions, and active educational programming, the museum has drawn students, teachers, scholars, and appreciators of art together to engage with American art of all periods and media. As the collections of the Addison have grown to encompass the range and depth of American art, we have been mindful of the special place that this area of New England has played in the hearts and minds of artists.

It is thus with particular pleasure that the Addison has collaborated with independent curator Trevor Fairbrother on the exhibition *Ipswich Days: Arthur Wesley Dow and His Hometown* and this accompanying publication. An Essex County native, Arthur Wesley Dow was a renowned artist whose reach was wide and whose art synthesized influences of diverse cultures. An extraordinary colorist, an artistic adventurer, and a profound teacher and mentor for the next generation of artists in the early twentieth century, Dow was also a devoted advocate for the quiet, pastoral parts of his hometown of Ipswich.

This project has offered the Addison the fortunate opportunity to work with a brilliant curator and good friend of the museum, to showcase a previously unknown photographic album of great art-historical interest and touching beauty, and to reveal the rich artistic collaboration of two devoted friends, Arthur Wesley Dow and Ipswich poet Everett Stanley Hubbard.

We offer our most sincere gratitude to Trevor Fairbrother for his exceptional work on this project, to Susan and John Moran for sharing the precious album with us and our audiences, and to all of those who treasure this wonderful part of the world and its contributions to our national cultural heritage.

For the Love of "Old Ipswich"

TREVOR FAIRBROTHER

This new look at the work of Arthur Wesley Dow developed in response to an album of forty-one photographs that is privately owned and previously undocumented. Titled *Ipswich Days* and dated 1899, it presents a sequence of images that moves nonchalantly between the town and its environs, interweaving clam shanties, marshes, farms, people, trees, flowers, and boats. Dow trimmed all the photographs to approximately four by five inches and housed them one per page in a commercially produced, hardbound, blank book (figs. 1, 2). The titles that the artist penciled beneath most of the pictures gave his layout a touch of formality; he occasionally noted a month or mentioned a local figure, for example, the farmer Nathaniel Low. The hand-lettered design at the beginning of the book contains a dedication to Everett Stanley Hubbard. Just two years younger than Dow, Hubbard was an artist and poet and longtime friend.

Both men grew up in Ipswich, Massachusetts, an old community located near the coast about thirty miles north of Boston. At a time when decay and new construction projects posed a double threat to the town's cache of pre-Revolutionary buildings, Dow's art— including *Ipswich Days*—recognized their aesthetic and cultural value. He expressed a love of Ipswich's old houses, her tree-shaded streets, and the river that twists its way through town and then flows into spacious tidal marshlands. New York became Dow's professional base after 1895, when he accepted a teaching position at Pratt Institute, Brooklyn. Despite this separation, his devotion to Ipswich was undiminished; he visited as often as possible and always summered there. Hubbard remained a lifelong resident of their hometown.

Ipswich Days is a token of an artist's attachment to a place and to a kind of soul mate. Dow may have created the album to mark Hubbard's fortieth birthday in 1899. The work is an important art-historical find, for it documents a crucial stage in a creative partnership. Dow wanted the album's wistful images to gratify and inspire his friend. A decade after Dow made a present of the photograph album, he and Hubbard brought out *By Salt Marshes: Pictures and Poems of Old Ipswich*. This book, produced in an edition of about 200 copies, had the hallmarks of the Arts and Crafts movement: restrained, orderly design; fine, honest materials; and handcrafting.[1] The motto for the publication, taken from one of Hubbard's poems, hinted at the lure of the unsullied marshland, "where life glides by in deeper moods and reveries than tongue can tell" (fig. 3).

The photographs in *Ipswich Days* impart much accurate information about Dow's

Arthur W. Dow and Minnie Dow at Their Gate, Spring Street, Ipswich, about 1901, hand-tipped gelatin silver print, 3 x 3 in. (7.62 x 7.62 cm). Addison Gallery of American Art, partial gift of George and Barbara Wright and partial purchase as the gift of R. Crosby Kemper through the R. Crosby Kemper Foundation.

world, but his idiosyncratic choice of the cyanotype process makes the pictures potent on the plane of dreams and desires as well. He loved the blue monochrome of cyanotype prints, delighting in their capacity to give reality a strange or otherworldly cast. Dow's choice was probably governed by aesthetic rather than cost factors; it should be noted, nonetheless, that commercial cyanotype paper was the least expensive and easiest way to make photographic prints. The artist would place a negative directly on top of the paper and make the exposure; the blue image appeared when the paper was washed free of chemicals. The cyanotype process was invaluable for reproducing architectural plans quickly and cheaply (the blueprint), but it was unpopular with photographers, who generally preferred the look of silver or platinum prints. In Dow's case the cyanotype's all-encompassing blueness contributed to the intrinsic feeling of pure, unified design he strove for in his art.

The essay that follows considers *Ipswich Days* from various perspectives: biographical considerations of both poet and artist; the maturing of Dow's artistic beliefs and practices; and Ipswich's importance as a muse for these idealistic individuals.

THE ARTIST

Arthur Wesley Dow was born in 1857 in an old wooden house on East Street, in the northeast corner of Ipswich. His mother kept house and his father was a weaver who did his work and sold his wares at home. Only two of their children—Arthur and his brother Dana (born in 1867)—lived past childhood. Around 1860 the family moved a very short distance to a newly built residence on the slope of quiet, rustic Spring Street.

Dow was a good student; after a few years at Ipswich's grammar school he attended high school in the larger town of Newburyport. He developed a keen interest in classical languages and French, and it was his wish to attend Amherst College when he graduated in 1875. His family could not afford this, but an adequate compromise emerged: Dow lived at home, taught elementary classes in a nearby parish school, and received private tuition from the Reverend John P. Cowles, an elderly scholar renowned as a teacher at the Ipswich Female Seminary. During this period Lydia Caldwell, head of the Ipswich Public Library, introduced Dow to her brother, the Reverend Augustine Caldwell, a Methodist minister in Worcester and an amateur historian passionate about Ipswich's past. Dow became Caldwell's protégé, translating French religious tracts

for him and tracking down early town records. In 1879 Caldwell started to publish *Antiquarian Papers*, a monthly pamphlet devoted to sundry findings about colonial Ipswich. In the fourth issue (January 1880) Dow contributed the first of his numerous illustrations. The subjects he drew or copied included the coats of arms found on tombstones and seals, houses and churches, and historical silhouettes (e.g., fig. 4).

One quaint edifice that Dow drew for *Antiquarian Papers* in 1880 was the house in which he was born (fig. 5). The accompanying text stated that the dwelling was built in 1638 and was later the home of a noted Puritan cleric, Thomas Cobbett. It is clear from this picture that Dow was self-taught: the perspective is off and the detailing of the landscape is clumsy. When compared with a photograph published four years later (fig. 6), the limitations of Dow's drawing are clear.

In March 1880 Augustine Caldwell recognized his young friend's work by naming him a copublisher. The two men also printed the writings of Abraham Hammatt, the first person to assemble information about Ipswich in the seventeenth century. During the five years he contributed to *Antiquarian Papers*, Dow experimented with printmaking; he chose historical subjects and advertised the results in the pamphlet.[2] This introduction to drawing and printmaking gave Dow the ambition, at

the age of twenty-three, to pursue a professional career as an artist. Caldwell and several genteel acquaintances sponsored his studies for a few years: in 1880, during visits to Caldwell in Worcester, Dow took lessons from Anna Freeland, a landscape artist; and in 1881 he began about two years of instruction in the Boston studio of James M. Stone, a portraitist and figure painter. He worked with tremendous dedication. In a sketchbook used in 1881 he wrote this maxim: "He who tires not tires adversity."[3] After acquiring additional skills in Boston, Dow embarked on his first experiences as an art instructor. As a way to support his own studies he offered classes in rented spaces in small towns in New Hampshire (Brentwood, Rumney, and Exeter) and Massachusetts (Clinton and Ipswich).

In 1884 Dow was ready to undertake advanced study in Europe, as his teacher James Stone had done. Like many aspiring American artists he chose Paris for this training, and spent a total of four years abroad (1884–87 and 1888–89). He enrolled at the Académie Julian, a large private establishment offering classes that were comparable to those taught at the state-run École des Beaux-Arts. Committed to landscape painting, Dow spent his summers sketching in rural Brittany. His goal was to have his work hung at the annual Paris Salon, an exhibition selected by a jury of French

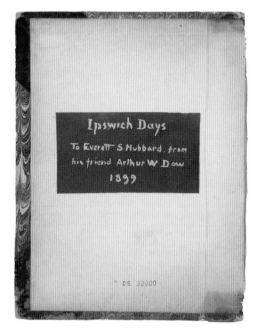

1

Title and dedication page from *Ipswich Days*.

2

Page from *Ipswich Days*, showing *Clamshell Alley* with the artist's pencil inscription.

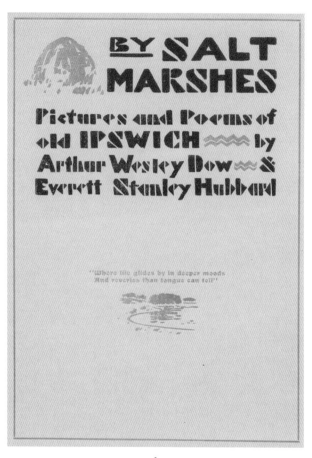

BY SALT MARSHES

Pictures and Poems of old IPSWICH 〰 by Arthur Wesley Dow 〰 & Everett Stanley Hubbard

"Where life glides by in deeper moods
And reveries than tongue can tell"

3

Title page of *By Salt Marshes* (detail), published in 1908 by Dow and Hubbard.
Ipswich Historical Society and Museums,
Ipswich, Massachusetts.

4

From a drawing by Dow, illustration in *Antiquarian Papers* 4, no. 51, January 1885.

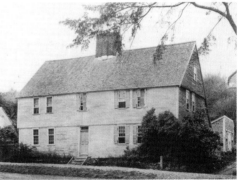

5

Detail of front page of *Antiquarian Papers* 1, no. 9, June 1880, showing Dow's *Rev. Thomas Cobbett's House.*

6

Heliotype Printing Co., Boston, *Rev. Thomas Cobbett's House,*

illustration in *The Celebration of the Two Hundred and Fiftieth Anniversary of the Incorporation of the Town of Ipswich, Massachusetts, August 16, 1884* (Boston: Little, Brown, and Company, 1884).

artists. Acceptance of a picture for that vast assembly was a vital step in a traditional career path. During Dow's time in France four of his paintings of Brittany landscapes were exhibited: in 1887 he had one work at the Salon; in 1889 he had two pictures in the Salon and one in the Universal Exposition (the world's fair that spawned the Eiffel Tower). In the last-named exhibition Dow earned an honorable mention with a painting of a farm at twilight.[4]

Immediately after his second sojourn in France Dow made *A Bit of Ipswich* (fig. 7) as an illustration for *The Visitor*, a new upmarket magazine published in Salem, Massachusetts. When compared with his 1880 picture of the Cobbett house (see fig. 5), this river view demonstrates many of Dow's new skills. He established a foreground with a casual line of plants and presented the river on a diagonal perspective leading the eye to distant hills; he rendered the workaday buildings as an attractive ensemble and evoked a lively play of light on their walls, the sails, and the reflections in the river. Dow also made a painting of the view in *A Bit of Ipswich*.[5]

The animated qualities of *A Bit of Ipswich* are evident when it is compared with a commercial topographical photograph made in the 1880s (fig. 8). The photograph, a view of the Ipswich River looking downstream from the Green Street Bridge, meticulously records

the shapes and surface textures of the clam shanties while giving the water a still, mirrorlike presence. In Dow's drawing, energetic marks and lines give life to all the ordinary things they depict. There are several photographs of the same stretch of river in Dow's album *Ipswich Days*, and two of them include fishermen's buildings (pp. 65, 69). While the commercial photographer had to please a business client, Dow could take pleasure in artistic effects of light and shadow.

The style and mood of Dow's work around 1890 show the influence of the direct, unaffected art of the Barbizon school, particularly the landscapes of Jean-Baptiste-Camille Corot and Jean-François Millet. Boston art patrons had supported the late romantic work of Millet since the late 1850s, and Dow would have been aware of it before traveling to Paris. Dow and Millet were of rural stock, and both approached nature with a sense of wonder. The young American would have recognized himself in the following comment by the Frenchman: "What I know of happiness is the quiet, the silence that you can savor so deliciously, either in the forests or in the fields."[6] Dow was surely gratified when a rather conservative French critic wrote in 1894 that he was "destined to take a prominent place" as an American landscape artist: "[Mr. Dow] works very hard, always in the country,

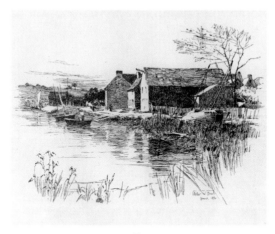

7

A Bit of Ipswich, illustration in *The Visitor*, May 28, 1890.

8

Heliotype Printing Co., Boston, *View from Green Street Bridge* (detail),
illustration in *The Celebration of the Two Hundred and Fiftieth Anniversary of the Incorporation of the Town of Ipswich*.

always watching the secrets of nature. He likes thick foliage, undulating grass, and is fond of reproducing the sudden turbulence of the sky and violent coloring, in which he excels. He knows the beautiful blue violet tones which prolong the distance and ornament pictures with a decided charm.... He belongs to the romantic school of Barbizon."[7]

In the early 1890s American painters of Dow's generation were investigating certain aspects of Impressionism. Despite a keen interest in color effects, Dow preferred not to be linked with the movement, which he regarded as a type of realism devoted to extreme procedures. He also dismissed the radical stylizations of such artists as Paul Gauguin, whom he encountered in Pont-Aven during the summer of 1888.[8] Dow's position as a modern artist was therefore more complicated than might be expected: he was no radical, but, as will be seen later in this text, in the 1890s he would question and transcend his academic training.

THE POET

Everett Stanley Hubbard, a farmer's son, was born in Ipswich in 1859. He died there in 1932, in the family home on East Street. Everett had three older siblings: Ida, Laura, and Francis (Frank). Ida, the only one to marry, settled in Worcester, Massachusetts, and the others spent their lives together on East Street. The only known likeness of Everett is the small profile portrait Dow made in the 1880s (fig. 9).

Information concerning Hubbard's education and adult life is scarce. Although he had begun to explore art and poetry, the census of 1880 listed him as a farm laborer. Presumably he and his brother Frank, another farm laborer, worked for their father. Dow later recalled the artistic inclinations they shared: "Mr. Hubbard and I were boys together in this country of the marshes, and here we have studied and painted" (see fig. 22). Hubbard and Dow were both involved with Augustine Caldwell's ventures by the late 1870s, and Hubbard made a few minor drawings for *Antiquarian Papers*. Early in 1882, when Dow was studying in Boston, Hubbard wrote his friend: "Art in Ipswich is at its lowest ebb (but whiskey isn't) and I cannot get anybody to sit to me any length of time."[9]

Hubbard was a quiet man, awkward in social situations. In July 1884 Dow had commented on his friend's glumness in a letter to a fellow artist, Minnie Pearson: "Mr. Hubbard is the same as ever—has no plans—gives lessons somewhere Saturdays. It is not very satisfying to talk with him or be with him because he has no interest in anything—yet there is a good deal in him—I would not give him up, for our

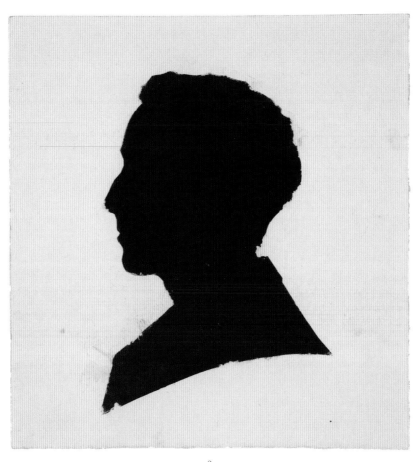

9
Everett Stanley Hubbard, c. 1880s,
cut paper on paper, 3 5/8 x 3 1/2 in. (9.2 x 8.9 cm).
Ipswich Historical Society and Museums, Ipswich, Massachusetts.

friendship has been very pleasant. Some day he will come out of himself perhaps.... Whenever anything is said about planning for the future he will say 'I can't, it takes money and friends to get ahead in this world—I have neither.'" [10] When Dow made these comments, the town of Ipswich was about to celebrate its two-hundred-and-fiftieth anniversary. The local newspaper published a booklet to commemorate the occasion that included speeches and historical reports. In his introduction to this publication the editor noted: "The illustrations are by Arthur W. Dow assisted by Everett S. Hubbard, both talented young artists, natives of Ipswich." [11] Hubbard probably sought a career in the fine arts, but today his only known pictures are the simple drawings reproduced in the anniversary booklet and the *Antiquarian Papers*. In 1893 Dow married Minnie Pearson, a well-to-do woman from Lowell, Massachusetts, whom he had met in the early 1880s as a fellow student of James Stone; he was thirty-six and she his junior by four years. After Arthur and Minnie Dow made New York their winter residence, they relied on Hubbard to do chores for them in Ipswich. Hubbard may well have helped the Dows at their "Ipswich Summer School of Art," which began to flourish in the late 1890s. Starting in 1901 he helped at the studio in the production of numerous modestly priced "Ipswich Prints." Dow conceived these works as study items that art teachers could use in the classroom; some were reproductions of his own compositions, others were his copies of details from Japanese textiles. An article in the new magazine *Handicraft* mentioned Hubbard as Dow's valued collaborator on the printing press, and commended his "uncommonly fine appreciation of what is aimed at." [12] Ipswich directories provide a few more facts about Hubbard: he was identified as an "artist in photo, crayon and oil" in 1891, a retoucher of photographs in 1897, and an artist in 1906.

Hubbard was writing poems by the early 1880s. According to one Ipswich historian, "Early in life he began to write poetry, winning praise from John Greenleaf Whittier, who expressed his admiration for him as both man and poet." [13] Whittier was a likely role model since he was born in Haverhill and lived in Amesbury, towns near Ipswich. Poems about rural life and colonial times were Whittier's forte, and his boyhood experiences of farm life primed their popularity. Hubbard's first poem to appear in print was "The Three Ships," a work inspired by the four-hundredth anniversary of the sailing of Columbus's fleet; it appeared in *The New England Magazine* in October 1892, embellished with drawings by H. Martin Beal, a young Boston artist. In his exhibition at the Museum of Fine Arts, Boston, in 1895 (see p. 27), Dow included two prints described in

the checklist as "page from the forthcoming book of poems by Everett S. Hubbard, to be illustrated, engraved, and printed by Arthur W. Dow."

In February 1896 Hubbard and Dow contributed to the first issue of *The Lotos*, a literary and artistic monthly published in New York. Dow's essay "The Responsibility of the Artist as an Educator" was followed by Hubbard's poem "The Pine."

The subject that was dearest to Hubbard and Dow was the marshland, which was the theme of their collaborative work *By Salt Marshes*. The poems and pictures in that book were anticipated by several of the photographs in Dow's *Ipswich Days* album. Marsh goldenrod appears in the album and inspired a poem and a print in their 1908 publication. *Ipswich Days* originally included a photograph titled *The Old Willow in the Hollow, October*, and a letter from Dow to Hubbard a few years later mentions "Willow in Hollow" as a work he wished to illustrate.[14]

By Salt Marshes, Hubbard's only book, marked the pinnacle of his literary career. Dow used the volume to encourage magazine editors to publish his friend's work, but his efforts were only modestly successful. In 1909 Hamilton Mabie of *The Outlook* accepted two poems about birds ("A June Humorist" and "The Thrush"), and the following year Richard Watson Gilder chose "Dance of the Willow-Leaves" for publication in *The Century Magazine*. Dow's letters to Hubbard during these years refer to numerous poems by title, but most went unpublished and the manuscripts have disappeared. From the same letters it is clear that Hubbard struggled with depression. In 1912 Dow urged his friend to heed the beliefs of John Burroughs and William James and to have faith in "the enormous power of the mind over the body." As a general practice he pushed Hubbard to "seize upon every influence for good that is within our grasp—sunshine, nature, companionship, books and healthful work."[15] Despite the encouragement of a dear friend, Hubbard lost his way. When he died, in 1932, the local newspaper published this reflection: "His life was as sweet and as delicate as his verse. While few knew him intimately those who did always acknowledged that in him burned the fires of genius."[16] A selection of Hubbard's poems may be found in the Appendix.

DOW'S TRANSFORMATION

Dow's activities as an artist and teacher underwent a vital shift in the early 1890s. Years later he spelled out this cathartic break with his education: "I confess to sympathy with all who reject traditional academicism in art. I often

regret the years spent in the Académie Julian where we were taught by professors we revered to make maps of human figures."[17] The source of Dow's frustration was probably the realization that his achievements in Paris in 1889 did little to advance his standing in Boston. Undaunted, he immersed himself in the city's libraries and art displays, hoping that "a comparative study of the art of all nations and epochs" would loosen the repressive grip of his academic training and help him to become a better resource for his students.[18]

The currents of modern art were unusually strong in Boston in the early 1890s: there was lively debate about the merits of Impressionism; the New York firm of McKim, Mead, and White was constructing a new Boston Public Library, arguably the finest civic building of the American Renaissance movement; and a circle of young artists and designers, including F. Holland Day, Ethel Reed, and Bertram Grosvenor Goodhue, championed Medievalism, Symbolism, and Art Nouveau in stylish and provocative ways. Japanese art, particularly color woodcuts, played the greatest role in Dow's transformation: "In 1889 I became acquainted with the Oriental collection at the Boston Museum of Fine Arts. In Japanese color prints and [the] methods of engraving them [I attained] full satisfaction of the love for color variations."[19] In an essay of 1893, published in the sumptuous Boston periodical *The Knight Errant*, Dow praised Japanese principles of design: "The Oriental composes more simply and more masterfully than the Occidental. [Regarding composition,] Japanese art is the best because [it is] so varied and so free from conventionality and limitation."[20] In 1899 he declared that the "restless inventive energy" that drives great artists was endangered in America: "In times when art is decadent, the designers and painters lack inventive power and merely imitate nature or the creations of others. Then comes Realism, conventionality, and the death of art."[21]

The catalyst for Dow's transformation was Ernest F. Fenollosa. Born in Salem in 1853 and educated at Harvard, this debonair man took office as the first curator of Japanese art at the Museum of Fine Arts, Boston, late in 1890. Prior to that appointment Fenollosa had spent twelve years in the employ of the Japanese government, teaching political economy and philosophy at the University of Tokyo, serving on national art committees, and directing the formation of the Tokyo School of Fine Arts. During those years he studied and collected Japanese art, and urged visiting Americans to do likewise. Dismayed by the government's promotion of western-style drawing and painting, Fenollosa crusaded for a Japanese national school that was a hybrid: the art should

have roots in native traditions while making a discriminating selection of innovations from the West. When working in Boston, he challenged contemporaneous American and European artists from a similarly dualistic position: he condemned entrenched realist practices and urged artists to study the simplicity and abstract clarity he admired in Japanese art. "Our public," he stridently claimed, "has been taught to stare at exhibition walls crowded with undigested transcripts of fact." [22]

After meeting Fenollosa early in 1891, Dow's drifting came to an end. In a two-person exhibition at the Boston Art Club in December of that year he showed numerous "Ink Paintings, based upon Japanese principles, and executed with the Japanese brush." They were landscape views of Ipswich, and the most elaborate was a six-panel screen decorated on one side with "Houses of ye Olden Time by Ipswich River." [23] In the spring of 1892, when Dow announced the method of instruction he would use in his upcoming summer classes, the imprint of Fenollosa's concepts was unmistakable. The curriculum was to include: "a special study of line, dark and light, and color, as synthetic principles; with reference to works of the Japanese masters, of early Italians, and of the modern French school; the aim being to develop [a] creative grasp in the rendering of subject, rather than any narrow line of abstract technique." [24] Those notions raised a few Bostonian eyebrows, but they were the principles that Dow utilized thereafter, notably in *Composition*, his groundbreaking volume on art education first published in 1899 and reprinted often thereafter. In an introductory note to that book he thanked Fenollosa for generating a "new conception of art" and constructing "an art-educational system radically different from those whose corner-stone is Realism." [25] Dow gave himself credit for "adapting these new methods to practical use" and further developing them in the classroom.

Key to the new methodology was the notion that art is "visual music." A sense of harmony and wholeness made fine objects akin to music, while those lacking beauty were like noise. Dow's brief to artists was to find a personal way to convey the beauty they saw in their subjects. He considered composition to be the foundation of all good art; therefore it had to be the first issue that pupils should appreciate. Dow taught his students that a successful work was an inspired combination of three active elements, which he named Line Composition, Dark-and-Light Composition, and Color Composition. He drew examples from rugs, architecture, pottery, and mosaics as well as paintings. Freedom to learn from a wide range of cultures and eras was one of the liberating aspects of Dow's teaching. The

painters and printmakers noted in *Composition* included early leaders of the Italian Renaissance (Giotto and Piero della Francesca), Japanese masters of line (Sesshu and Hiroshige), and select contemporary or recently deceased figures (Corot, William Morris Hunt, Anton Mauve, Pierre Puvis de Chavannes, and James McNeill Whistler).

Dow's comparative approach is evident in four illustrations from *Composition* (fig. 10). They are part of a larger group of illustrations in the section devoted to the second of the three basic aesthetic elements, the arrangement of "Dark-and-Light." In his layout Dow deftly grouped reproductions of landscapes by Francis Seymour Haden, Mori Ippo, John Constable, and Whistler. He wanted students to characterize each artist's arrangement of the masses of dark and light. While Constable chose to finish his picture with a degree of detail, and Ippo favored swift, evocative effect over facts, they both created "visual music" with Dark-and-Light. Fenollosa and Dow favored the Japanese term *Notan* for this fundamental aspect of art; and they stressed that it not be equated with the western interest in drawing shadows.

In 1898 Dow demonstrated advanced ways of arranging dark and light masses in two bold images in a manual for art instructors published by the Prang Educational Company (fig. 11). In the brightly lit upper picture, the string of buildings sits back in the landscape in a picturesque manner: the foreground feels expansive and plants of different sizes distance the viewer from the main house. In the lower picture, which is reminiscent of dawn or late afternoon, the structures join together visually as one expanse of dark tone; the composition has a more horizontal emphasis, the landscape plays a lesser role, and the sky has a more emphatic and jagged silhouette.

Meadow Hay (fig. 12) exemplifies the fresh style that Dow explored in the 1890s. The composition has clarity, and the play of the darks and lights is serene. The recession of space is evident in the quiet rhythm of similar curves: the mounds of hay, the treetops, and the hilly horizon. The low light level gives an opportunity to strike a few sonorous color notes near the top of the canvas, particularly the dark blues and greens of the distant foliage and the orange-ocher of the moon. Dow composed this picture with the kind of simplicity that he most admired in Japanese art and in works by a few contemporaries. Thus a comment that Dow made in 1893 about the leading French muralist is relevant to his own twilight landscape: "Puvis de Chavannes knows how line and ethereal color can express the repose, the eternal calm of the ideal." [26] *Meadow Hay* also reflects Dow's keen interest in a Dutch

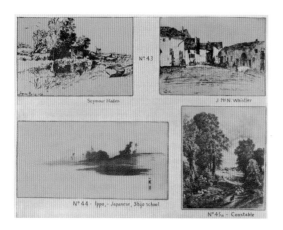

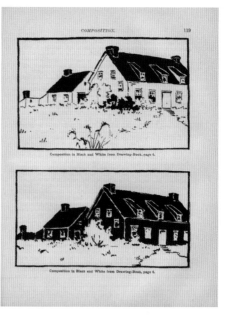

10
Detail of page 40 in Dow's *Composition*, 1899.

11
Page 119 in John S. Clark et al., *Teachers' Manual Part II, for The Prang Elementary Course in Art Education, Books 3 and 4, Fourth Year* (Boston: Prang Educational Company, 1898).

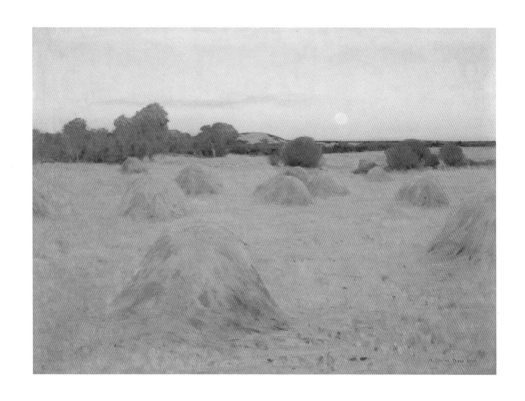

12
Meadow Hay, 1894, oil on canvas, 22 x 36 in. (55.9 x 91.4 cm).
Ipswich Historical Society and Museums, Ipswich, Massachusetts.

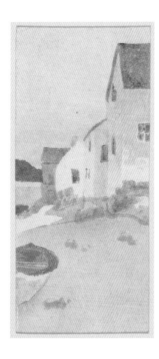 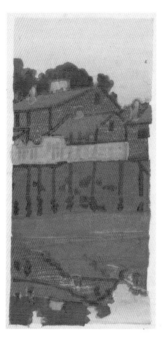 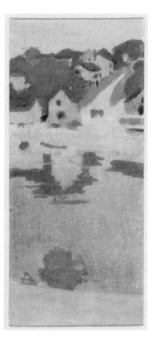

13
Clam Houses, c. 1893–95, color woodcut, 5 x 2 1/4 in. (12.7 x 5.7 cm).

14
Little Venice, c. 1893–95, color woodcut, 4 11/16 x 2 3/8 in. (11.9 x 6 cm).

15
A Hill Street, c. 1893–95, printed 1899, color woodcut, 5 x 2 1/4 in. (12.7 x 5.7 cm).
All three Addison Gallery of American Art, partial gift of George and Barbara Wright
and partial purchase as the gift of R. Crosby Kemper through the R. Crosby Kemper Foundation.

artist influenced by the Barbizon School: "The works of Anton Mauve form an instructive example of a truly artistic method of expression. He has this in common with some of the best Orientals, viz., the attainment of his purpose by the simplest means—few lines, few tones, quiet color, and, above all, directness."[27]

Dow's transformation in the 1890s is particularly evident in a group of color woodcuts that measure about five by two-and-a-quarter inches (figs. 13–16). Strikingly tall and narrow, with exquisitely cropped, asymmetrical compositions, they embodied the artist's desire to transcend the strictures of western realism by embracing Japanese styles and techniques. Dow drew each composition, carved the different blocks used for its various color elements, and printed the image. Thanks to his acquaintance with Ernest Fenollosa he could study fine Japanese prints at the Museum of Fine Arts, particularly after being hired in 1893 as the curator's part-time assistant. Dow was working on a picture-book of his woodcuts, titled *Along Ipswich River*, in 1893, and two years later he installed over 200 of them in the "Japanese Corridor" at the Museum of Fine Arts. There were fifteen compositions, all views of Ipswich. He printed multiple copies of each subject, but made every print unique by varying the palette and changing the manner in which he pressed the paper against the different blocks.

At the museum he displayed many prints as individual works of art, but others he gathered in groups; for example there was a set of six different subjects printed with colors that evoked "snow landscapes."[28] In an essay of 1896 Dow characterized his method of printing as "painting with wooden blocks," and he cited Hiroshige's print series *Fifty-Three Stations of the Tokaido* as the "immediate stimulus" for his Ipswich woodcuts.[29]

Fenollosa wrote an informative essay in the catalogue published by the museum, praising Dow's independent and original application of "oriental principles...to the rendering of characteristic beauties in New England scenery." Rarely able to resist an opportunity to grandstand, he pronounced the project an "epoch-making event."[30] The exhibition won the approval of the *Boston Evening Transcript*, the city's most cultured newspaper: "Mr. Dow is a landscape painter of refinement.... He uses the [Japanese] process freely for expression of his own motives, and...his subjects and his manner are equally original.... There is a peculiar piquancy in the alliance of Essex County landscape themes to Japanese methods of expression."[31]

Dow enjoyed the "constant surprises" to be had when taking an inquisitive and playful approach to making woodcuts. "If you tire of printing a river blue," he wrote in 1896,

"you can, in the next proof, change it to purple or yellow." [32] The fact that the medium favored "color variation" helped Dow steer away from academic principles: "Its strength lies in free interpretation, in a *playing* with colors, so to speak, rather than a forced realism. It lends itself readily to a suggestive rendering of effects of nature—a twilight, moonlight, sun and shadow, rain, gray days and morning mists—but it as easily permits a departure into a purely imaginative treatment as brilliant and unreal as stained glass." Openness to the "purely imaginative" and the "unreal" signaled Dow's commitment to artistic freedom of an anti-academic sort. He also liked to point out that everyday life offers color lessons to those who are observant. Dow recalled experiences in his youth that showed him the expressive potential of color: the slapdash hand-coloring of old children's primers ("a green boy in a blue tree"); the yearly repainting of the boats that worked the Ipswich River; and the endlessly changing color combinations when these bright vessels flashed against "the blue river or purple mud flats or...faded sea grass." [33]

In 1897 Dow exhibited a group of his Ipswich woodcuts at the inaugural exhibition of the Society of Arts and Crafts, Boston, the first organization of its kind in America. In the catalogue he referred to his contribution as a "collection of wood paintings, engraved upon wooden blocks and colored," and indicated that he had "designed and executed" them. He was clearly proud of the fact they were entirely his handiwork, and he knew that his ideals were in synch with the Arts and Crafts movement that would soon proliferate across the country.

AN ALBUM OF PHOTOGRAPHS

There are three known albums of photographs by Dow, and *Ipswich Days* is the only one with a title and a dedication in his hand. [34] It readily gives viewers a strong, uplifting impression of the maker's favorite haunts. Further reflection reveals that many of its cyanotypes are analogous in style and spirit to his best woodcuts and paintings of the period. *Ipswich Days* and *Composition* both date from 1899, and each book may be seen as a manifestation of Dow's drive to turn deep artistic concerns into chaste and simple forms. The following words from *Composition* can be a useful touchstone when assessing the quality of Dow's photographs in *Ipswich Days*: "The difference between a commonplace design and a beautiful one may be very slight—it can be felt, but not described." [35]

Dow generally avoided visual elements that appear informal or accidental, and very few

of the pictures in this album can be characterized as snapshots. His skilled looking is revealed when he isolated an area within a negative and declared this second, tighter composition an independent work of art. Such is the case with a photograph of the town center that he included in *Ipswich Days*. Titled *Looking Toward the Old Bridge* (p. 119), its composition is the left half of the larger picture reproduced in figure 17. "Little Venice" was Dow's affectionate name for this cluster of buildings that used tall wooden piles to support their riverside facades. Both of these cyanotypes have remarkable qualities. The uncropped print (fig. 17) has a panoramic breadth, and its right half is patterned with numerous vertical accents, including a grand tree with branches that reach beyond the picture's top. The photograph with the tighter view (p. 119) focuses on the curve of the river near the Choate Bridge, which can be glimpsed near the left edge, in the distance; in this picture an extensive watery foreground distances the buildings and church in a romantic fashion. Dow clearly felt that the latter image was more appropriate for *Ipswich Days* than the expansive horizontal picture it came from. The composition of *Treadwell's Island Marshes* (p. 99) is another example of the same selective process. Dow "found" this beautiful picture in another of his negatives: it was the center section of a horizontally orientated picture.[36]

Many of the landscapes that Dow chose for *Ipswich Days*—meadows, woods, country roads, river views, and dunes—were also the subjects of his paintings, prints, and drawings. The album's first image, *The Thicket*, portrays a site that he drew in pencil in a sketchbook around 1897 (fig. 18). Since the drawing and photograph both use monochrome, they offer a good opportunity to see Dow's artistic choices regarding the play of dark and light elements. The contrasts of tone are more dramatic in the drawing, where the distant trees serve as a black background for the bushes in the middle ground. These two works also serve as a reminder that Dow was happy to revisit a favorite subject, for it is likely that he painted in the same field in the previous decade. His solo exhibition at a Boston gallery in 1888 included a painting titled *The "Thicket" Pasture, Ipswich*, which was described in the *Ipswich Chronicle* as "a scene with cattle, taken near the Greenwood farm on a bright summer morning."[37]

A photograph taken in June (p. 59) is a classic example of Dow's love of Ipswich's intriguing balance of hills and marshland. He stood on a grassy slope overlooking the winding river; from that vantage point the gentle curves of more low hills played against the sky, and the only vertical accents were tree trunks and a few fence posts. Compositions of this type abound in Dow's work, including a woodcut

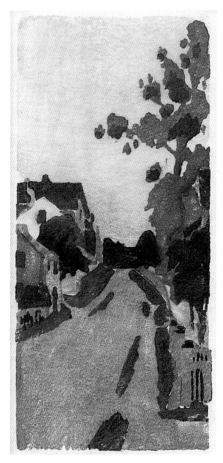

16
Ipswich Street, 1895, color woodcut, 5 1/8 x 2 1/2 in. (13 x 6.4 cm).
Collection of Spanierman Gallery, LLC, New York.

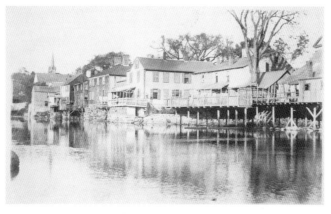

17

Houses by the River, Ipswich, Massachusetts, 1890s, cyanotype, 5 x 8 in. (12.7 x 20.32 cm).
Addison Gallery of American Art, partial gift of George and Barbara Wright
and partial purchase as the gift of R. Crosby Kemper through the R. Crosby Kemper Foundation.

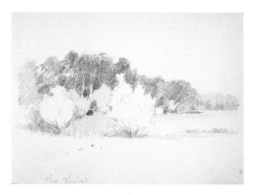

18

The Thicket, c. 1897, pencil on paper, in sketchbook, 4 1/2 x 6 7/16 in. (11.4 x 16.5 cm).
Ipswich Historical Society and Museums, Ipswich, Massachusetts.

poetically titled *The Marshes, from Bayberry Hill, Effect of Rain* (fig. 19). Another way in which he evoked the undulating landscape was to stand at the bottom of hill and look towards its summit. Views of this sort often inspired compositions with high horizon lines and dramatic contrasts between near and far elements. *Old Stone Wall and Tansy* (fig. 20) is a perfect example: Dow devoted much of the picture to the asymmetric rhythms of the weathered boulders and the clumps of tansy; in the upper right the wall has become a beautiful thin line following the rise of the landscape.

Marsh islands are prominent in three photographs in the album (pp. 85, 87, 89), and are background elements in others. These discrete tracts of land sit higher than the tidal creeks, and they support the growth of trees and shrubs. Marsh islands are the dominant, most stable elements in a very changeable landscape, and Dow often gave them and their reflections key roles in his compositions. He also employed the silhouette of a marsh island as an emblem in his publications: one example appears in *By Salt Marshes* (see fig. 3), and another, set beneath a line of Greek characters that spell "synthesis," was the mark on the title page of all editions of *Composition*.[38]

The counterparts to Dow's marsh views are found in his photographs of Ipswich's architectural landscape. *Clamshell Alley* and *The Old House on the Corner* demonstrate his ability to portray an attractive building (pp. 71, 121). These works also show his sensitivity to the ways in which successful buildings occupy their sites and dignify their surroundings. Dow's album of photographs contains two views of the section of town he called Little Venice (pp. 117, 119). He made the same large building a key element in each composition; in one picture (p. 117) he faces downstream; in the other he looks towards the arches of the Choate Bridge, a landmark stone structure built in 1764. Dow took pleasure in depicting the same subjects at different times of day, from diverse vantage points, and in a variety of media, which is confirmed by the diversity of his pictures of Little Venice. For example, the three buildings huddled at the far right of one of his photographs (see fig. 17) take center stage in a classic color woodcut (see fig. 14). Dow omitted various details when designing this print, most tellingly the large tree growing next to the low building. His studies of Japanese art had taught him that a good artist knows what *not* to include in a picture.

Dow generally excluded people from his paintings and drawings. It is somewhat surprising, therefore, to find him giving figures an active role in nine of the photographs in *Ipswich Days*. Four are portrait images that include Dow. Three of these show him relaxing

in the yard of the family house on Spring Street (pp. 73, 81, and 129, in which he sits beside his brother, Dana). The fourth—the album's only indoor and only non-Ipswich picture—portrays Dow and the Rhode Island–born painter Henry Rodman Kenyon in their Paris studio (p. 131). The other compositions with prominent figures position their subjects in the middle distance, where they add to the ambience of the setting and help establish a sense of scale. Dow's memorable view of a shipyard (p. 93) includes a girl in a light summer dress: a bowsprit and an assortment of tackle dwarf her charming and unexpected presence. Two farm pictures show a hay wagon being loaded by a pair of workers whose bodies are set against the sky (pp. 107–9). Two pastoral compositions position a reserved, fashionably dressed man (probably Dow) amid a cluster of shapely young trees: in the first he reclines and faces the viewer (p. 99); in the second he walks down a hill holding something near his chest (p. 115). If Dow appears in as many as six pictures, it is possible that someone helped him with the camera on these occasions. Several of his friends and acquaintances in his Ipswich circle are known to have been involved in photography.[39] In *Ipswich Days* there are a few photographs with people in the distance: the figures are so small that they are hard to detect (pp. 65, 69, 71). The fact that they "disappear" so gracefully

testifies to Dow's ability to keep the viewer's attention focused on the simple lines and masses of his compositions.

Most of the photographs in *Ipswich Days* were made during an eventful and creative period in Dow's life. In 1895 Ernest Fenollosa helped him secure a teaching position at the Pratt Institute in Brooklyn. That year Fenollosa moved to New York because the trustees of the Museum of Fine Arts learned of his adulterous relationship with an employee.[40] For a few years Dow juggled appointments in both cities. In September 1897 he was promoted to keeper of Japanese paintings and prints at the Museum of Fine Arts; he held the position on a part-time basis for two years before deciding to focus completely on teaching in New York and running his summer school in Ipswich.[41] It is possible that Dow undertook his extensive photographic record of Ipswich during this period because the images were useful to him during his months in New York, either in the classroom at Pratt or in the studio where he worked on his own art. It should not be assumed, however, that he made photographs solely as studies for his works in other media. Since Dow's mind was quick and playful and his reiterations of the same subjects were frequent, his photographs surely played multiple roles in his oeuvre.

Dow was fascinated by photography and produced hundreds of cyanotypes; but he

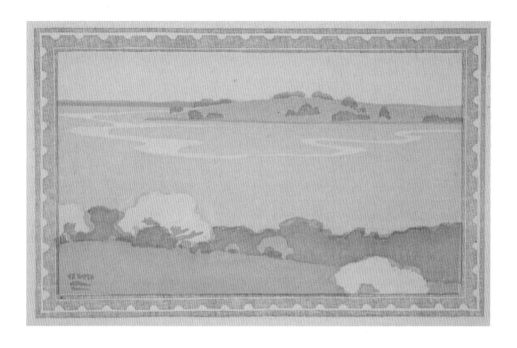

19
The Marshes, from Bayberry Hill, Effect of Rain, color woodcut in *By Salt Marshes*, published 1908.
Ipswich Historical Society and Museums, Ipswich, Massachusetts.

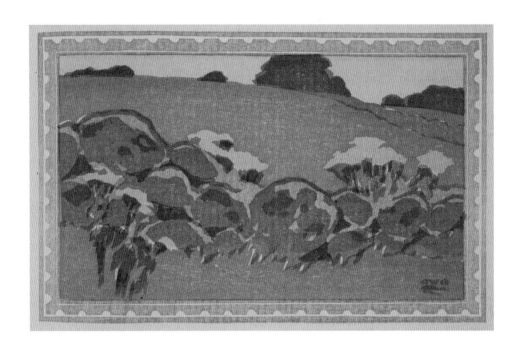

20

Old Stone Wall and Tansy, color woodcut in *By Salt Marshes*, published 1908.
Ipswich Historical Society and Museums, Ipswich, Massachusetts.

made virtually no effort to exhibit or promote his photographic works.[42] A few pictures resulting from his visits to France suggest that he had begun to make use of the camera in the 1880s, but he was most productive between 1890 and 1910. Dow believed a photograph to be a work of art when its maker undertook an enlightened aesthetic process. He was an early supporter of Gertrude Käsebier, a New York photographer with a professional portrait studio. In an essay published in *Camera Notes* in 1899 Dow wrote: "[Her work] shows that she chooses the artist's point of view, that a portrait is not a mere record of facts.... She chooses to paint her portraits with the camera and chemicals. She takes the scientific process and makes it obey the will of the artist.... She gets her effects with a common tripod camera, in a plain room with ordinary light and quiet furnishings. Art always shows itself in doing much with few and simple things."[43] Near the end of his life Dow reiterated these views in a short essay for *Pictorial Photography in America 1921*: "Modern photography has brought light under control and made it as truly art-material as pigment or clay.... [The modern photographer] can control the quality of his lines, the spacing of his masses, the depth of his tones and the harmony of his gradations. He can eliminate detail, keeping only the significant. More than this, he can reveal the secrets of personality. What is this but Art?"[44]

In the early years of the twentieth century Dow was close to many of the American artists who championed photography as an art form. Alvin Langdon Coburn studied with him at the Ipswich Summer School in 1902 and 1903; they both served as jurors for the Wyoming Valley [Pennsylvania] Camera Club in 1907; and they photographed together in the Grand Canyon in 1911–12.[45] It is clear that Dow took a professional interest in the medium and built connections with several leading modern photographers. After he became director of the fine arts department at Columbia University's Teachers College, he quickly reformed the curriculum and brought in many new teachers, including photographers. Dow tried to hire Alfred Stieglitz, who declined; in 1907 he hired, on Stieglitz's recommendation, Clarence H. White.[46] But Dow never sought broad recognition as a photographer, despite his ability to produce work as sophisticated as that in *Ipswich Days*. It was the popularity of his book *Composition* that made him a great, though unheralded, influence on the practice of photography. Dow's contributions to American photography were not explained until the 1990s, when a historical survey of the medium made this assessment: "Dow's emphasis [in *Composition*] on the flatness and inherent abstraction of all pictures prompted photographers to think of the camera as a fundamentally

graphic—rather than illusionistic—tool. [His] ideas provided a formal vocabulary for a generation of Pictorialist photographers while pointing the way to the fully nonobjective photographs of the late 1910s and 1920s."[47]

IPSWICH AS MUSE

Everett Stanley Hubbard and Arthur Wesley Dow grew up in a town that had a special old-fashioned feel, and each of them sealed it in his imagination as an ideal place. The short texts about their poems and pictures included in *By Salt Marshes* (reproduced in figs. 21 and 22) make it clear that Ipswich was their muse. They were roughly fifty years old when they made their collaborative book, and the place they portrayed so lyrically had largely disappeared with their youth. Factories and numerous modern services were changing the look of Ipswich, and citizens with diverse cultural and religious backgrounds were joining a community formerly composed of white Anglo-Saxon Protestants.

Dow's campaign to raise awareness about "old Ipswich," began with his contributions to *Antiquarian Papers*. He came to maturity during a period when the picturesqueness of old New England was a staple of contemporary American art. Winslow Homer and Eastman

Johnson shaped this genre after the Civil War, and Homer's work as a commercial illustrator popularized it. Homer, for example, drew some pictures for an illustrated edition of Whittier's *Ballads of New England* published in 1870. Dow began to consider the synthesis of art and literature in 1889, when he produced landscape paintings in which a small area of the composition was decoratively inscribed with lines of poetry; one example quoted J. Appleton Morgan, and another included the first verse of Celia Thaxter's "Heartbreak Hill."[48] In 1898 Dow and Augustine Caldwell revisited their publishing days when they compiled and published two slim books titled *Old Ipswich in Verse*. Dow designed the image printed on both covers (a view towards the foot of Summer Street from across the river), and the project included two of Hubbard's poems ("Harry Main" and "The Pine"). The following year found Dow planning to become an author: he drew a pencil sketch for the cover of a book titled *Marshes and Moraines*.[49] His notations indicated that it would be of "pictures alone or of poems and pictures." This drawing is dated 1899, the year he gave *Ipswich Days* to Hubbard. *Marshes and Moraines* was abandoned, but it was clearly the seed from which *By Salt Marshes* grew.

It was impossible for Dow to separate his artistic interest in Ipswich from his sense of civic responsibility towards the town in

The Poems

Eastern Ipswich is preeminently a country of beautiful distances. The peace and tranquillity of the scenes that prompted the following verses have touched me since childhood. Even beneath storms and high winds the marshes and rolling hills seemed to me, beyond most landscapes, to lie serene and unchanged. The nearby trees might rock and toss, but still the distance would somehow remind me of an impressive human countenance, immobile and introspective.

As to the composition of the verses I will only say that I used the pen more with the spirit and feeling of a worker in plastic art than as a man of letters. Indeed, these impressions were set down with but small thought for the canons of literary art; and, perhaps it will be well to add, with but slight knowledge of those precepts.

Everett Stanley Hubbard

21

"The Poems," page from *By Salt Marshes*, published 1908.
Ipswich Historical Society and Museums, Ipswich, Massachusetts.

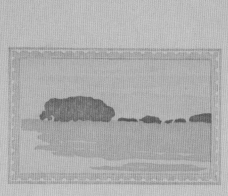

The Pictures

Salt marshes set about with round-topped hills, barberry hedges along old stone walls that climb over the upland pastures, grassy spaces patterned with savin and bayberry, wild apple trees in the thickets, wide fields of daisies and frost flowers, shore lines of goldenrod and scarlet lilies, dark marsh islands, far and near, reflected in creek and salt pond, haystacks crowding into the horizon's perspective, a blue line of sea beyond the distant sand hills; such is the familiar Ipswich landscape, varied by season and sky and tide.

Mr. Hubbard and I were boys together in this country of the marshes, and here we have studied and painted. For this reason I find a special pleasure in making these color prints to accompany his songs.

The pictures, designs, and lettering of titles are frankly the imprint of the knife-engraved wood block.

Arthur Wesley Dow

"The Pictures," page from *By Salt Marshes*, published 1908.
Ipswich Historical Society and Museums, Ipswich, Massachusetts.

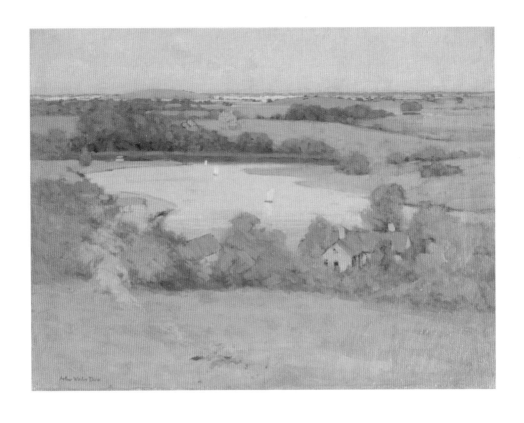

23
An Ipswich Distance (View of the Marshes, Ipswich), c. 1907, oil on canvas, 18 x 24 in. (45.7 x 60.9 cm).
Worcester Art Museum, Worcester, Massachusetts,
Stoddard Acquisition Fund.

which he was born. He was a founding member of the Ipswich Historical Society in 1890, and a year later he made a speech to the local board of trade outlining his suggestions for making the town "more delightful as our own abiding place" and more attractive to visitors and tourists. "Ipswich," Dow declared, "is a beautiful old rural town and ought to be so always, no matter how much its wealth increases." He suggested that all new buildings should be consistent with those that had given the town its distinct character, rather than copies of the modern citified architecture in other municipalities. And he argued that outlying roads should not be overly improved: "Let the wayside flowers stay and bloom. Leave the barberry bushes and old mosses, and stone walls. Plant trees and beautify the road where it needs it, [then] let nature do the rest." [50] In 1900 Dow purchased a seventeenth-century colonial building, the Emerson House, to save it from destruction. He quickly put it to use as a work-place for students attending his annual summer school. His instinct to stand in the presence of visually intriguing old artifacts when introducing students to contemporary art was as uncommon as it was inspiring. The year 1900 also marked the start of a personal construction project in Ipswich: Dow had purchased land behind his home on Spring Street, atop the area known as Town Hill, and

this site was to have a studio with a magnificent view across the marshes to the sea.

Dow's painting *An Ipswich Distance* (fig. 23) stems from the same moment in his career as *By Salt Marshes*. He may have chosen the title in response a remark Hubbard made in that book: "Eastern Ipswich is preeminently a country of beautiful distances" (see fig. 21). Dow painted an idyllic landscape that was free from overtly modern incursions—pastures that had been cleared by previous generations; a few traditional wooden buildings; three small sailboats; and a small fire that produces a graceful trail of smoke in the foreground. *An Ipswich Distance* is a charming and sophisticated example of the artist's desire to "use some beautiful groupings of lines and shapes, chosen from the scenery of the old New England town, as a groundwork for different color-schemes, a pattern, so to speak, for a mosaic of hues and shades." [51]

At one of the events marking the twenty-fifth anniversary of the Ipswich Historical Society in 1915 Dow shared his thoughts on "Ipswich from the artist's point of view." The notes for his speech divided the town's attractions into two categories: first the natural scenery, then those "treasured things of beauty that have come to us from former generations." [52] Under the second heading he included relics—houses and furniture—and early cases of civic

improvement, for example the elm trees that "our fathers planted along our streets." One of the entries he included on a list of topics to be discussed extemporaneously was "Everett's poems."

When discussing the landscape Dow praised the numerous hills that "give a setting for Ipswich scenery." Then he spoke of the contrast made by the marshes, which he deemed the most characteristic and most beautiful feature of the area: "Changing from hour to hour with the rise and ebb of the tides, and from month to month with the seasons' advance, they are always new, always surprising us with unexpected light and color." Referring to a traditional set of themes dear to Japanese painters— "The Eight Beautiful Scenes of Omi"—Dow offered to select the "choice views of Ipswich," and he flattered the audience by saying that the town had "many times eight" attractive views.[53]

Dow and his wife had no children, and they honored Ipswich in their wills. They gave the town approximately eighteen acres of land for use as a public park; and they donated the Emerson House to the Society for the Preservation of New England Antiquities, along with an endowment to fund its maintenance. Dow asked that his executors place a commemorative boulder in the new park. When they did so in 1934, they attached a metal plaque bearing the words of his bequest: "I give to the Town of Ipswich, Bayberry Hill (so-called by me) within said town, with a commanding view, which is dear to me, over the marshes, creeks, rivers, and hills to the ocean, to have and to hold by said town and its inhabitants forever, for the use of the public as a place of recreation and enjoyment."

Those words affirm the artist's everlasting love of the haven he named Bayberry Hill. While he wanted the gift of land to last "forever," Dow knew from experience that its surroundings would change. Not long after he had completed the studio his vista was marred by new construction: a Boston lawyer erected a grand Italianate summer house at the foot of Dow's hill. Time has brought numerous changes since the artist's death. The land he gave to the town survives nearly intact but it has been neglected: trees and scrub now block all views of the marshes.[54] Intimations of Dow's world await contemporary visitors willing to devote time to Ipswich and the marshes, and his art— fresh and vital—retains its power to inspire.

NOTES

1. The book was self-published in Ipswich in 1908. Dow showed it for the first time in his solo exhibition at the Montross Gallery, New York, in February 1908. He made thirty-five copies available for sale at the gallery. A few days before the opening he told his co-author: "We ought to print enough for 200 copies as soon as we can." Letter from Dow to Everett Stanley Hubbard, January 26, 1908, Dow Papers, Ipswich Historical Society and Museums, Ipswich, Massachusetts (all subsequent citations to letters in Ipswich Historical Society are in this collection).

2. Several kinds of pictures were mentioned in different issues of *Antiquarian Papers*: heliotypes made from drawings; lithographs; engravings; and "cuts or plates." A decade later Dow described his first prints: "Roughly engraved woodcuts which I colored by hand or printed on tinted papers, often using the green or yellow covers of old almanacs...[and lithographs] of landscape in outline, which were afterwards colored." Dow recalled using the handle of a toothbrush to press the paper against the block or the lithographic stone. See Arthur W. Dow, "Painting with Wooden Blocks," *Modern Art* 4 (July 1896), p. 87.

3. Another version of this saying is "He who does not tire, tires adversity." The sketchbook, which is owned by the Peabody Essex Museum, Salem, Massachusetts, contains drawings that range in date from June 1880 to December 1881. It includes a few quotations from poems, including Edgar Allan Poe's "The City in the Sea" and "Dream-Land."

4. To put Dow's achievement in perspective, it should be noted that twenty-three other American artists received an honorable mention that year.

Greater awards—grand prizes, and gold, silver, and bronze medals—went to fifty-seven Americans. There were 108 American exhibitors who went without official recognition. See Annette Blaugrund et al., *Paris 1889: American Artists at the Universal Exposition* (Philadelphia: Pennsylvania Academy of the Fine Arts; New York: Harry N. Abrams), p. 27. This catalogue illustrates Dow's painting on p. 148.

5. The painting is *Turkey Shore*, 1890, collection of the First National Bank of Ipswich, Massachusetts. That title is erroneous because the drawing and painting depict a boathouse and other buildings on Water Street near the bottom of Hovey Road. For an early photograph of the site, see William M. Varrell, *Ipswich Revisited* (Charleston, SC: Arcadia Publishing, 2006), p. 14.

6. Letter from Millet to his patron Alfred Sensier, February 1, 1851, quoted in Alexandra R. Murphy, *Jean-François Millet* (Boston: Museum of Fine Arts, 1984), p. 65.

7. S.C. de Soissons, *Boston Artists: A Parisian Critic's Notes* (Boston: Carl Schoenhof, 1894), pp. 47–48.

8. For a good overview of Dow's criticism of Impressionism and the works of Gauguin and van Gogh, see David Sellin, *Americans in Brittany and Normandy, 1860–1910* (Phoenix: Phoenix Art Museum, 1982), pp. 53–54.

9. Letter from Hubbard to Dow, dated "Jan. 1882," Ipswich Historical Society. In this letter Hubbard offered to paint a portrait of Dow's father at no cost, adding: "All that I want is the practice."

10. Letter from Dow to Miss Pearson, July 9, 1884, Ipswich Historical Society. A month later Augustine Caldwell wrote Dow that Hubbard "has rather gone into his shell again." Caldwell to Dow, August 7, 1884, Ipswich Historical Society.

11. I. J. Potter, "Introduction," *Chronicle Report of the 250th Anniversary Exercises of Ipswich, August 16, 1884, Together with a Few Sketches about Town* (Ipswich: Chronicle Press, 1884), p. 3.

12. Sylvester Baxter, "Handicraft, and its Extension, at Ipswich," *Handicraft* 1 (February 1903), pp. 265–66. The article notes that Hubbard operated a "little press" that was "run by foot-power." The first set of "Ipswich Prints" was published in 1902 in an edition of 800; in the text accompanying the six pictures Dow did not acknowledge Hubbard's contribution. For illustrations of the third set of Ipswich Prints (*Six Sketches Reproduced from the Japanese*, 1902), see Julia Meech and Gabriel P. Weisberg, *Japonisme Comes to America: The Japanese Impact on the Graphic Arts, 1876–1925* (New York: Harry N. Abrams, 1990), p. 175.

13. Arthur W. Johnson, "An Appreciation of E. S. Hubbard," *Ipswich Chronicle*, September 2, 1932.

14. Letter from Dow to Hubbard, March 15, 1909, Ipswich Historical Society. *The Old Willow in the Hollow* is the only cyanotype known to be missing from *Ipswich Days*. A page inscribed with the title falls between those for images on pages 73 and 75 herein.

15. Letter from Dow to Hubbard, September 25, 1912, Ipswich Historical Society. Dow wrote: "I don't know whether you are familiar with the works of William James, the greatest of modern teachers (Henry James' brother). The enormous power of the mind over the body is being understood better and better. Christian Science has hold of the right end of the matter, but Mrs. Eddy did not have a monopoly on this."

16. Johnson, "An Appreciation of E. S. Hubbard."

17. Dow was speaking at the Annual Meeting of the College Art Association in Philadelphia, and his paper was published the following year: "Modernism in Art," *American Magazine of Art* 8 (January 1917), pp. 113–16.

18. Arthur Wesley Dow, *Composition: A Series of Exercises Selected from a New System of Art Education* (Boston: J. M. Bowles, 1899), p. 5.

19. Dow, "Painting with Wooden Blocks," p. 87. The literature makes much of a supposed eureka moment in February 1891 when Dow "discovered" Japanese art while examining illustrations of Hokusai's prints. In a letter (now lost) the artist apparently claimed that he previously admired Whistler as an original, but now realized that he was "only copying the Japanese." See Frederick C. Moffatt, *Arthur Wesley Dow* (Washington, DC: Smithsonian Institution Press for National Collection of Fine Arts, 1977), p. 48 and p. 135 n24. Dow surely knew of the connections between Whistler's art and Japanese prints in 1889, for his own work was mentioned in an article that discussed Whistler and Hiroshige at length: Theodore Child, "American Artists at the Paris Exhibition," *Harper's New Monthly Magazine* 79 (September 1889), pp. 492–98, 518.

20. Arthur W. Dow, "A Note on Japanese Art and on What the American Artist May Learn Therefrom," *The Knight Errant* 1 (January 1893), p. 117. The essay appeared in the fourth and last issue of the magazine, which was founded and co-edited by Ralph Adams Cram, a young architect devoted to a modern revival of Gothic style.

21. Dow, *Composition*, p. 18.

22. Ernest F. Fenollosa, *Mural Painting in the Boston Public Library* (Boston: Curtis and Company, 1896), p. 15.

23. See the brochure for the exhibition, *Pictures by Mr. F. H. Tompkins & Mr. Arthur W. Dow*, The Boston

Art Club, December 5–21, 1891. Dow was represented by sixteen ink paintings, three watercolors, twenty-two oil paintings, and several "Sketches and Studies" in oil.

24. Dow's announcement for his Ipswich class in landscape painting, as quoted in an unsigned column, "The Fine Arts," *Boston Evening Transcript*, April 11, 1892. The article closed with a jab at Dow: "This programme is ambitious, to say the least, and it might perhaps have been well to add, for the benefit of very young students, that there is no royal road to art, synthetic or otherwise."

25. Dow, *Composition*, p. 5.

26. Dow, "A Note on Japanese Art," p. 116. Dow had recently expressed similar thoughts in a letter to a local newspaper. When it was rumored that the Frenchman might be commissioned to paint mural decorations for the new Boston Public Library, Dow wrote in support of the idea: "The work of Puvis de Chavannes, true poet and true artist, is on a far higher plane than most of the art of the present day, being abstract, spiritual, full of infinite meaning, [and] farthest removed from realism which is 'of the earth.'" See Arthur W. Dow, letter to the editor, *Boston Evening Transcript*, January 23, 1892.

27. Arthur W. Dow, "Mauve's Painting: An Example of Pure Artistic Expression," *Modern Art* 3 (Autumn 1895), p. 119.

28. Dow illustrated his 1893 design for the cover of the *Along Ipswich River* portfolio in his 1896 essay "Painting with Wooden Blocks," p. 86. There is no known copy of this publication with all its prints. According to the catalogue the fifteen subjects in Dow's exhibition at the Museum of Fine Arts were: 1. Ipswich from the River. 2. Fish-houses along the Shore. 3. Gables by the Old Bridge. 4. A Lean-to. 5. A Hill Street. 6. Low Tide.

7. Ipswich River and Distant Marshes. 8. Shipyard Lane. 9. Roofs on Old High Street. 10. From the Bridge. 11. Near the Wharf. 12. From Hovey's Hill. 13. Norton's Brook. 14. Shore of Plum Island River. 15. Among the Moraines.

29. Dow, "Painting with Wooden Blocks," p. 87.

30. Ernest F. Fenollosa, "Introduction," *Special Exhibition of Color Prints Designed, Engraved, and Printed by Arthur W. Dow* (Boston: Museum of Fine Arts, 1895), p. 3. Fenollosa was always a forceful advocate; consider, for example, his statement that Sesshu was "the sanest, strongest, and most typical Japanese artist of the last six hundred years, if not of all time." See Fenollosa, *Japanese Paintings and Metal Work, Lent by Mr. F. Shirasu* (Boston: Museum of Fine Arts, 1894), p. 4.

31. "Exhibition of Color Prints by Mr. Dow in the Museum of Fine Arts," *Boston Evening Transcript*, April 23, 1895.

32. Dow, "Painting with Wooden Blocks," p. 90.

33. Ibid., p. 90 and p. 86.

34. The Addison Gallery of American Art, Andover, Massachusetts, owns an album with black pages and thirty-two gelatin silver prints that are approximately three inches square; Dow inscribed titles for the works in red-brown ink; most of the images show Ipswich, but a few were taken in California. The Museum of Fine Arts, Boston, owns a ledger-like album containing 264 cyanotypes, many of them approximately five by eight inches; many of the works show Ipswich, but others were taken in Essex, Lowell, Marblehead, Newburyport, and on Mount Adams, New Hampshire. Dow organized the pictures in this large album thematically, and inscribed an index with page references at the beginning.

35. Dow, *Composition*, p. 20.

36. The Addison Gallery owns a platinum print of the full composition (acc. no. 2007.10.100). For a reproduction see James L. Enyeart, *Harmony of Reflected Light: The Photographs of Arthur Wesley Dow* (Santa Fe, NM: Museum of New Mexico Press, 2001), pl. 15. A third example of a cropped composition is *Paris Studio—Kenyon and Dow, 1888* (p. 131), which is the center section of a photograph reproduced in Moffatt, *Dow*, p. 41.

37. "Mr. Arthur W. Dow's Exhibition," *Ipswich Chronicle*, January 14, 1888. J. Eastman Chase's Gallery, Boston, presented the exhibition, which included thirty-nine paintings. The *Chronicle* said that "the largest and most important" work on view was the one that had been hung in the Paris Salon of 1887 (*A Field, Kerlaouen, Finistère*).

38. For a discussion of the "synthesis" design featured on the title page of *Composition*, see Moffatt, *Dow*, p. 85. Dow referred to his method of teaching as the Synthetic Method because its roots were in design and composition; he presented it as the antithesis of the Academic Method, which was centered on accurate representation and "learning to draw." See Arthur Wesley Dow, *Theory and Practice of Teaching Art*, 2nd ed. (New York: Teachers College, Columbia University, 1912), pp. 2–5.

39. The photographers in Dow's circle there included his brother, Dana; Everett Hubbard; George Dexter (a successful commercial photographer in Ipswich); and the amateur ornithologist Dr. Charles Wendell Townsend. I am grateful to Stephanie Gaskins for her thoughts on this subject.

40. Fenollosa's mistress was the writer Mary McNeil Scott; she became his assistant at the Museum of Fine Arts in autumn 1894 and his wife in December 1895. While living in New York, the couple worked together to launch the new magazine *The Lotos*:

there were five issues in all, from February to September 1896. The Fenollosas began a four-year sojourn in Japan in the summer of 1896. The best biographical account is Lawrence W. Chisolm, *Fenollosa: The Far East and American Culture* (New Haven, CT: Yale University Press, 1963).

41. Dow's title was "keeper of Japanese paintings and prints" according to his only contribution to the museum's annual report (for the year 1898). When Dow's appointment was first announced (in the report for 1897) he was called "curator" "for the ensuing year." In the first edition of *Composition*, published early in 1899, Dow identified to himself as "Curator of the Japanese Paintings and Prints, Boston Museum of Fine Arts; Instructor in Composition at Pratt Institute and at Art Students' League of New York." In a letter to the artist Benjamin Tupper Newman, October 25, 1899, Dow wrote: "I have given up my place at the Museum. They needed somebody there all the time, and have decided to put a young man in there. I could not give over 4 days per month. The young fellow [Walter M. Cabot] is green at it but can learn." Benjamin T. Newman Papers, Archives of American Art, Smithsonian Institution, roll 331, frames 524–88.

42. I have found documentation for only one exhibition in which Dow included his photographs: his solo show at the Montross Gallery, New York, February 4–15, 1908, included eight "Photographic Studies of Oriental Architecture and Sculpture." Recent literature often notes that Dow was a regular participant in exhibitions of photographs, relying, I assume, on a remark published in 1977. Frederick Moffatt described "a small photograph by Dow of the Ipswich marshes," bearing an inscription indicating that it had won first prize "at an unknown

date at the Boston Photograph Club." See Moffatt, *Dow*, p. 145–98. The Ipswich Historical Society owns this work and houses it with its Dow materials, but there is no record of its origin. The photograph is attached to a dark brown cardboard mount with decorative embossing; the inscription on the verso indicates that Velox Special Portrait paper was used to make the print. On stylistic grounds I strongly doubt that Dow took the picture, and the inscription is not from his hand. The Boston Photograph Club cannot be documented. The writer probably meant the Boston Camera Club, but no evidence has been found to indicate that Dow exhibited with that organization.

43. Arthur W. Dow, "Mrs. Gertrude Kasebier's Portrait Photographs: From a Painter's Point of View," *Camera Notes* 3 (July 1899), p. 22. *Camera Notes* was the official publication of the Camera Club of New York. When Dow's essay was published, Alfred Stieglitz was the club's vice president and chairman of the publications committee.

44. Arthur Wesley Dow, "Painting with Light," in *Pictorial Photography in America 1921* (New York: Pictorial Photographers of America, 1921), p. 5.

45. David Acton notes an exhibition of the Wyoming Valley Camera Club, in Wilkes-Barre, Pennsylvania, in his catalogue *Along Ipswich River: The Color Woodcuts of Arthur Wesley Dow* (New York: Hirschl & Adler Galleries, 1999), p. 27.

46. See Bonnie Yochelson, "Clarence H. White: Peaceful Warrior," in Marianne Fulton, ed., *Pictorialism into Modernism: The Clarence H. White School of Photography* (New York: Rizzoli, 1996), pp. 26–32.

47. Keith F. Davis, *An American Century of Photography: From Dry Plate to Digital*, 2nd ed., rev. and enl. (Kansas City, Mo.: Hallmark Cards; New York: Harry N. Abrams, 1999), p. 59.

48. These paintings are known only through early photographs in the collection of the Ipswich Historical Society.

49. Collection of the Addison Gallery. Dow indicated that the cover design would be "in gold and one color," and would include the words "Designed and printed in color by the author."

50. Arthur W. Dow, "Ipswich as It Should Be, From an Artist's Point of View," *Ipswich Chronicle*, May 9, 1891.

51. Dow, "Painting with Wooden Blocks," p. 86.

52. Dow, "Remarks at Historical Dinner," lecture notes, August 17, 1915, Ipswich Historical Society.

53. Ibid. The eight Ipswich subjects were: 1. Moonrise at Baker's Pond. 2. Circle Willows at Plum Island. 3. Willow Reflections from Green Street Bridge, Summer. 4. Flood Tide in the Marshes, November, seen from Town Hill, Castle Hill, Argilla Road, [or] Common Fields. 5. Meeting House Green with the Elms, October. 6. Barberry Pasture in the Snow. 7. The Baker Elm and the Old Bridge. 8. Ipswich at Sunset, from Turkey Shore. Dow crossed out one item—"The Thicket in Autumn"—and replaced it with the Meeting House Green subject.

54. Dow's studio on Bayberry Hill burned in 1930, the year before Minnie Dow's death. By the early 1940s that section of the park had fallen into private hands and the remaining acreage was allowed to grow wild. In the 1990s Ipswich resident Susan Howard Boice successfully petitioned the town to cut a trail that allows the public to walk to the boulder with the commemorative plaque. In the 1980s the Society for the Preservation of New England Antiquities started the process whereby the property that Dow bequeathed them—the Emerson House—could be sold; the building is now privately owned.

Ipswich Days

To Everett S Hubbard, from
his friend Arthur W Dow
1899

ARTHUR WESLEY DOW
Ipswich Days, 1899
Bound book with 41 cyanotypes
Collection of John T. and Susan H. Moran

Each print, approximately 4 x 5 or 5 x 4 in. (10.2 x 12.7 or 12.7 x 10.2 cm);
book overall, 7 3/4 x 6 x 5/8 in. (19.7 x 15 x 1.6 cm)

All album photographs that follow are shown with borders and croppings made by Dow,
accompanied by the titles provided by the artist (those images not titled by the artist are shown without identification).

The Thicket

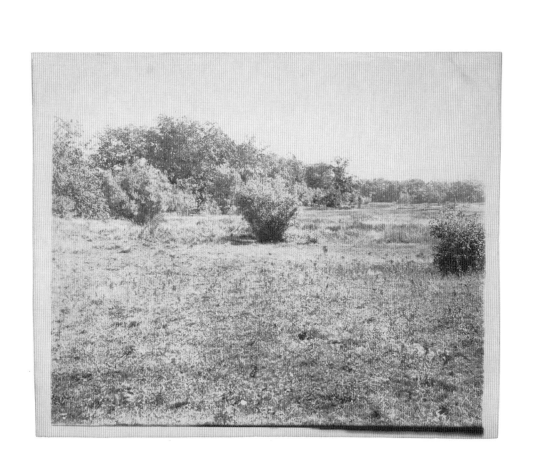

Pasture and Marshes

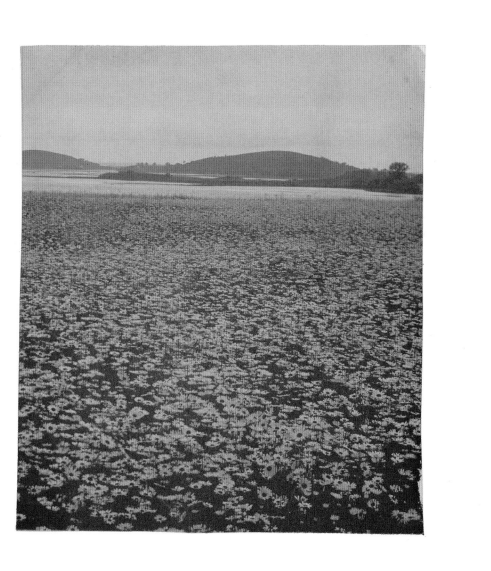

Haystack on the Upland

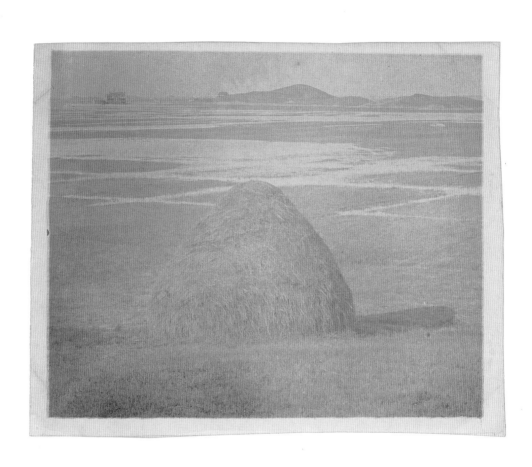

The Farm Road

June – Sagamore Hill and Ipswich River

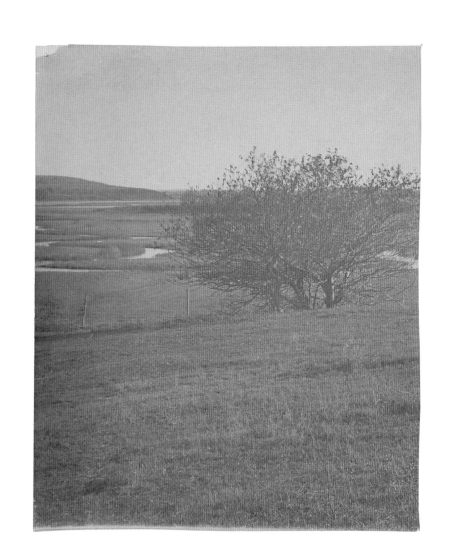

The Cove and Old Shipyard

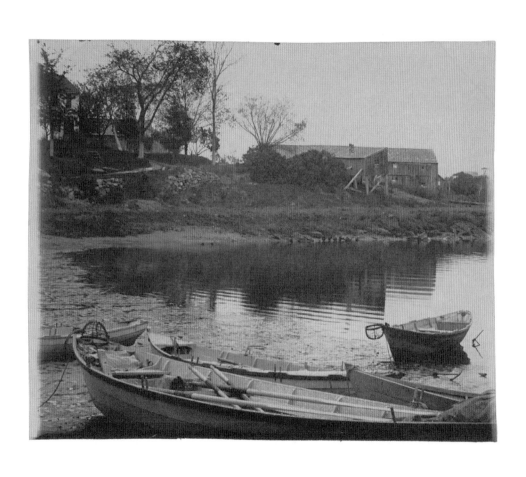

Billy Lord's – The Haunted House

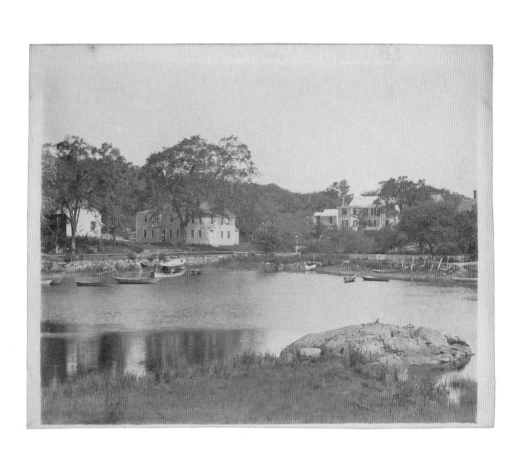

The Town Landing

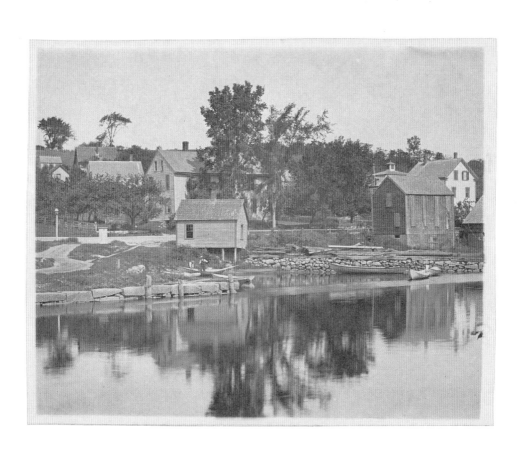

Willows on Turkey Shore

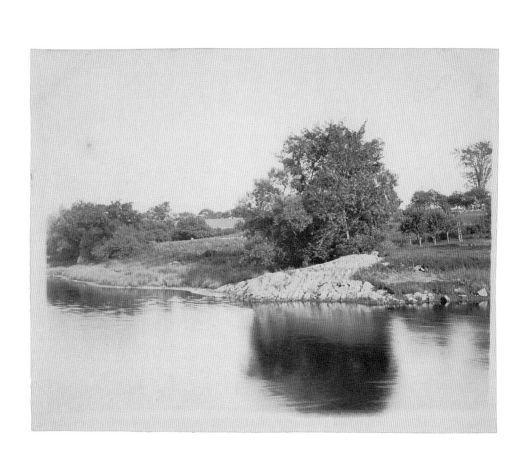

Shipyard Lane

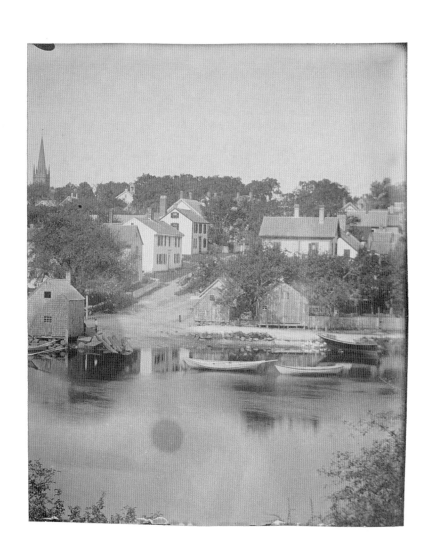

Clamshell Alley

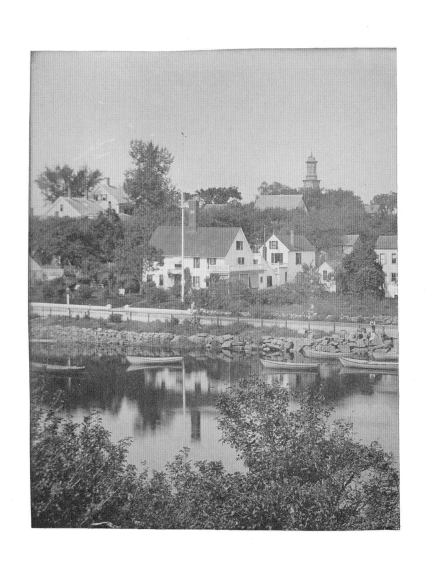

"Up'm Peter's"– A November Day

The Flood Tide

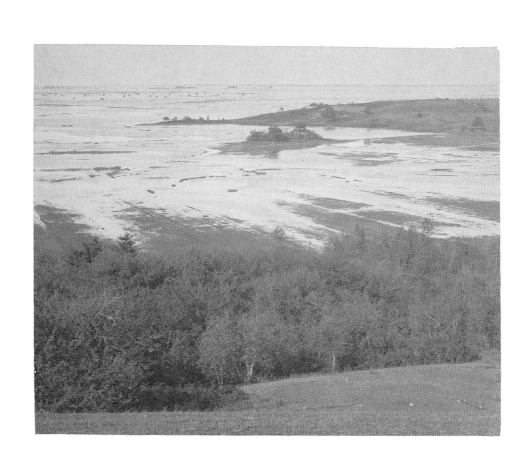

Green's Point Road

Marsh Goldenrod

A Marsh Island

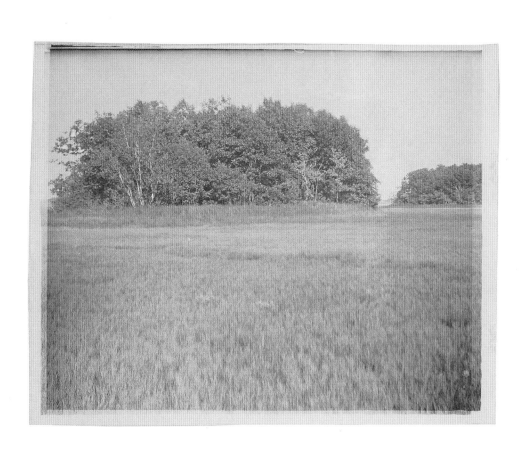

A Summer Tide

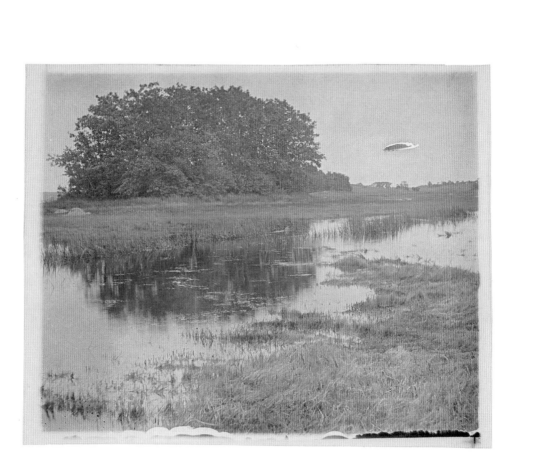

Marsh Island and Sagamore Hill

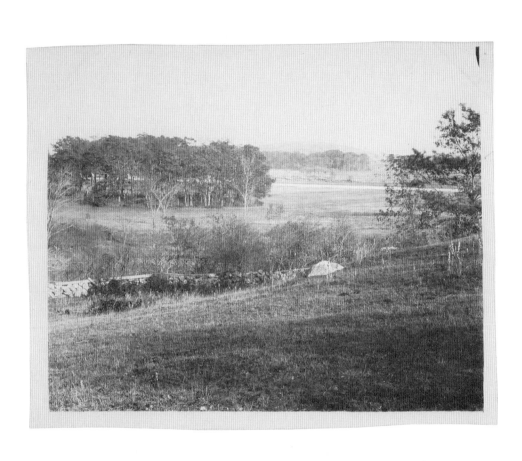

October – Choate Island

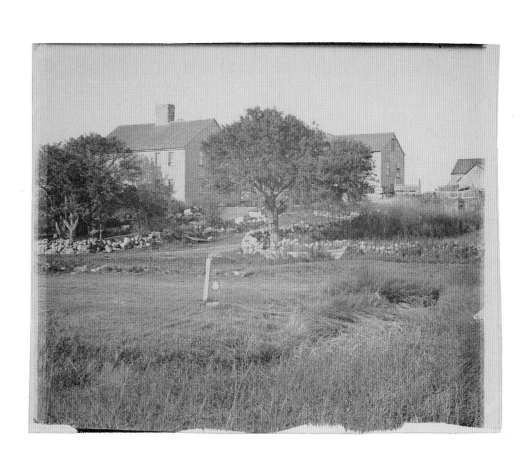

Evening – Essex Shipyard

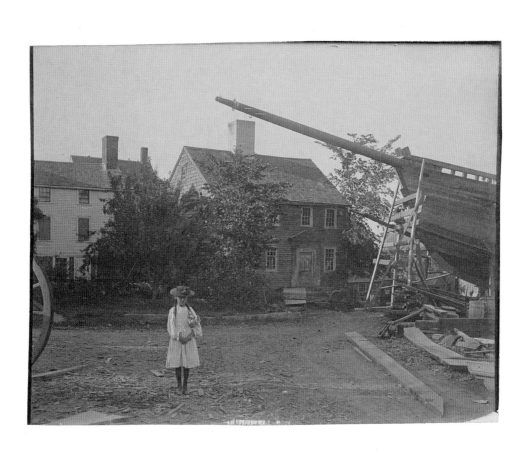

The Beach Road

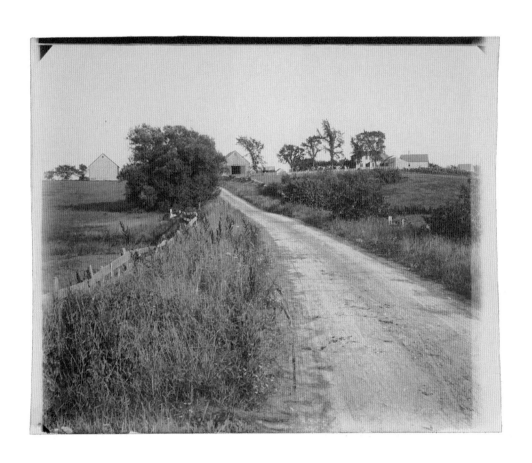

The Cherry Tree in the Snow

Treadwell's Island Marshes

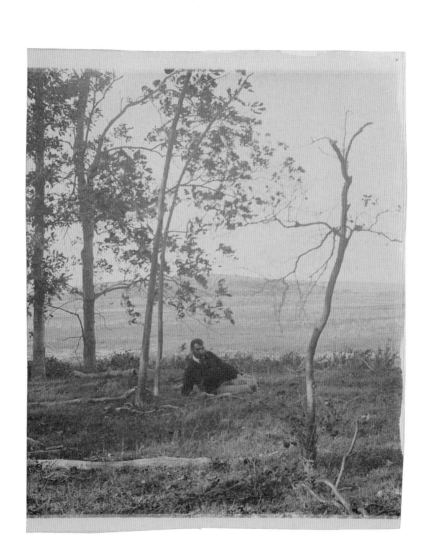

Among the Sand Hills, Plum Island

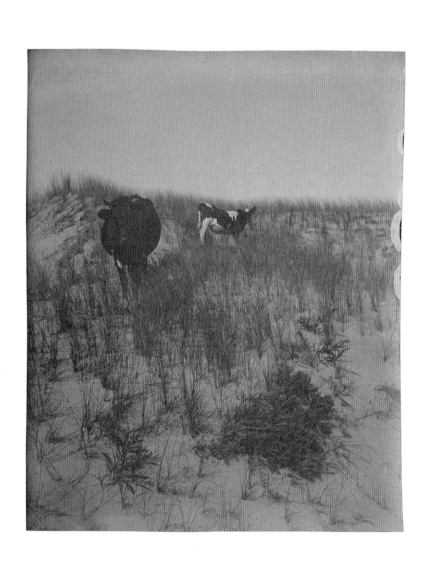

Ipswich Beach

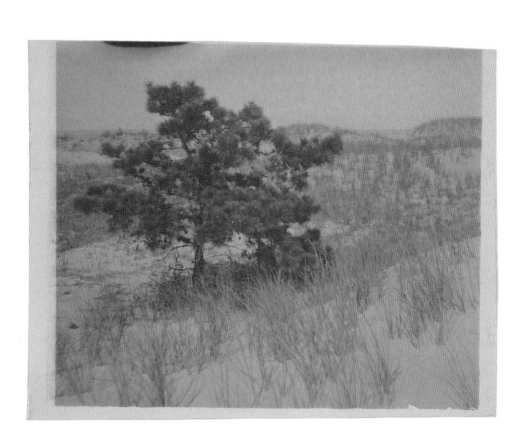

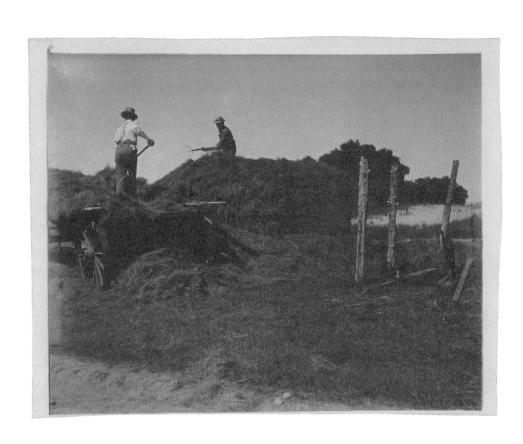

Stacking

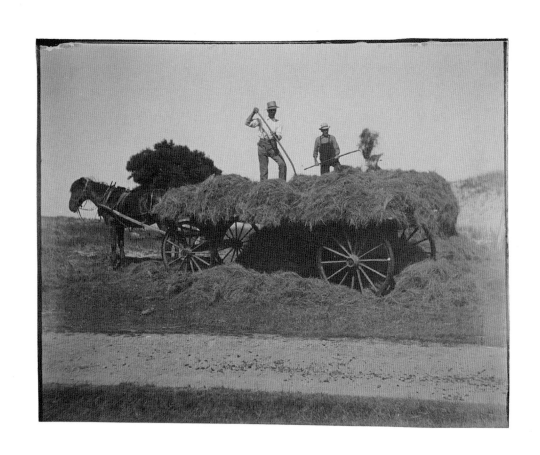

The Wild Iris

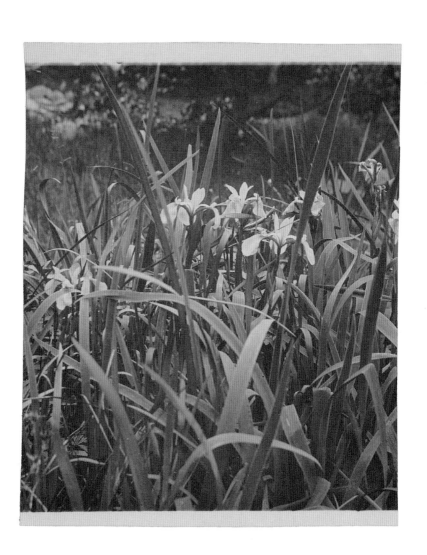

The Old "Sanders"– Plum Island Sound

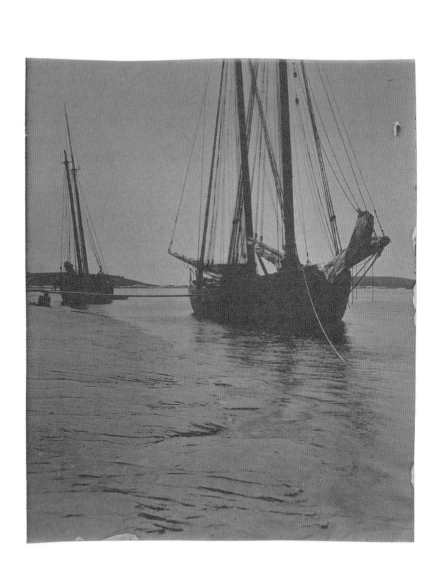

At the "Birches"– April

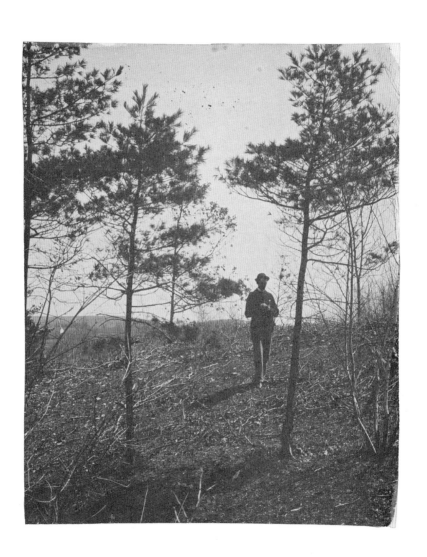

"Little Venice"

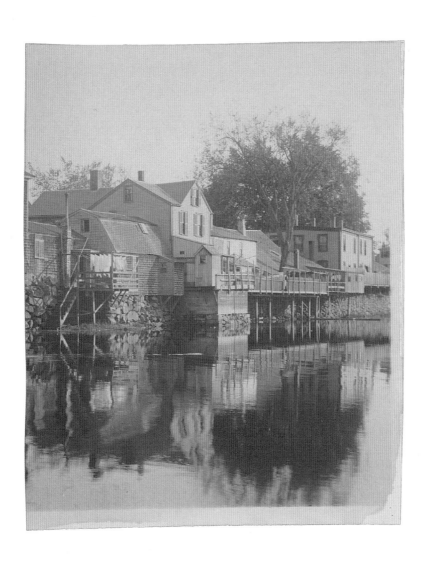

Looking Toward the Old Bridge

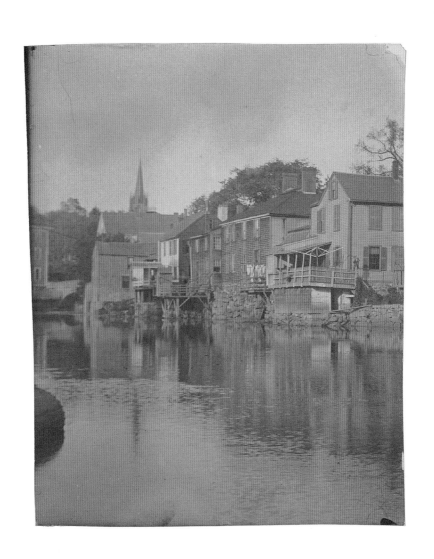

The Old House on the Corner

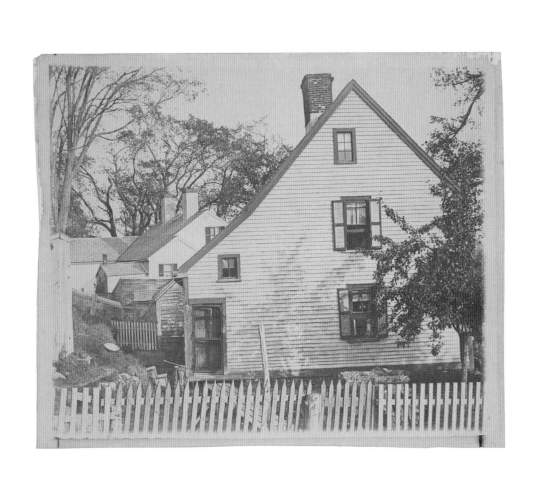

'Than Low's Woodland

'Than Low's Brook

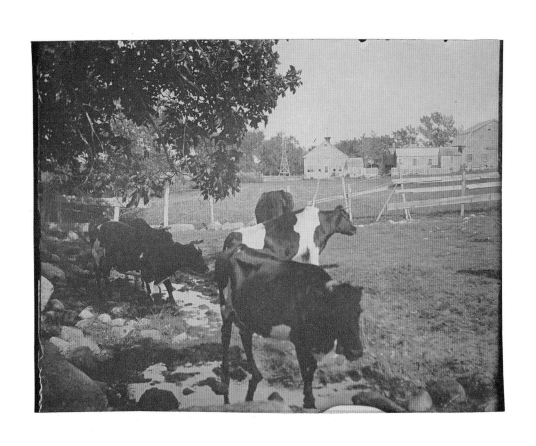

The Incoming Tide – Marshes by Heartbreak Hill

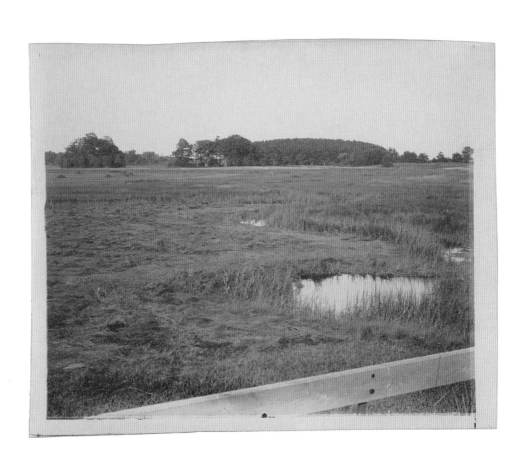

Two Brothers, 1897

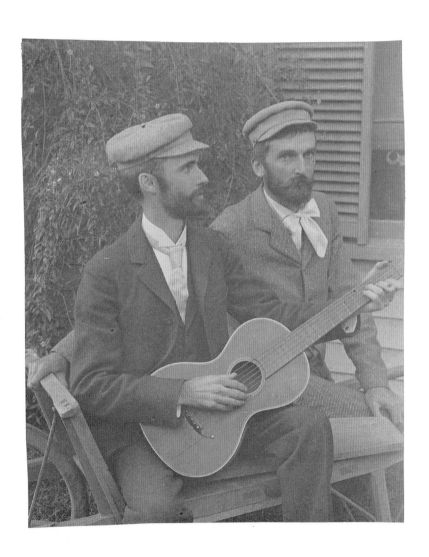

Paris Studio – Kenyon and Dow, 1888

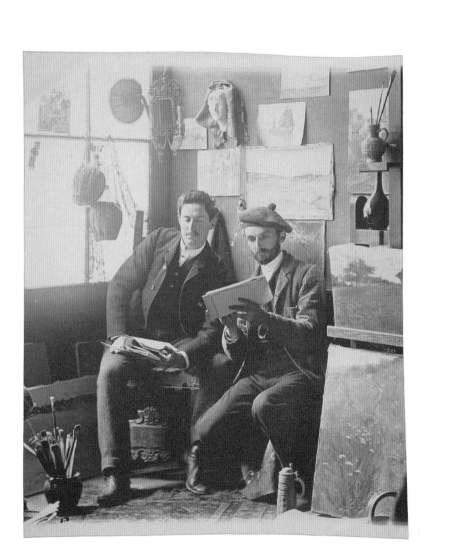

1857 Born, April 6, Ipswich, Massachusetts.

1875 Graduated from the Putnam Free School, Newburyport, and began teaching elementary classes at Linebrook Parish School, Ipswich.

1880 Contributed the first of numerous illustrations to *Antiquarian Papers*, a monthly pamphlet devoted to the early history of Ipswich.

1881 Became the pupil of the painter James M. Stone in Boston.

1884 Moved to Paris to study at the Académie Julian.

1885 Spent seven months in Pont-Aven on the coast of Brittany.

1887 One of his Breton landscape paintings exhibited at the Paris Salon. Returned to Ipswich.

1888 J. Eastman Chase's gallery, Boston, hosted Dow's first solo exhibition.

1888–89 Returned to France to paint landscapes in Brittany. In 1889 two of his paintings shown at the Salon and one at the Universal Exposition, Paris.

1890 Moved to Boston. Paintings by Dow and Walter Gilman Page shown in joint exhibition at J. Eastman Chase's gallery, Boston.

1891 Participated in joint exhibition with Frank H. Tompkins at Boston Art Club. Offered art classes in Boston. Presented the first annual Ipswich Summer School of Art.

1892 Influenced by Ernest F. Fenollosa, curator of Japanese art at the Museum of Fine Arts, Boston, Dow's emphasized East Asian aesthetics for the first time at his Ipswich Summer School.

1893 Married Minnie Pearson. Began work as part-time assistant to Fenollosa at the Museum of Fine Arts, Boston.

1895 Exhibited his color woodcuts at the Museum of Fine Arts, Boston. Accepted a teaching position at Pratt Institute, Brooklyn, New York.

1896 Studied early Italian art in Tuscany and Venice in the summer.

1897 Spent part of the summer painting in Scituate, Massachusetts, with Denman Waldo Ross, a wealthy collector and trustee of the Museum of Fine Arts, Boston. In the fall Dow was appointed keeper/curator of that museum's collection of Japanese art.

1898 Began to teach occasional classes at Art Students' League, New York.

1899	First edition of *Composition* published in Boston. Dow makes *Ipswich Days* album.
1901	Exhibited paintings and color woodcuts at the Pan-American Exposition, Buffalo, New York.
1902	Traveled to Nova Scotia in the summer with the Rev. T. Franklin Waters, fellow member of the Ipswich Historical Society.
1903	*New York Times* reported that 130 pupils attended Dow's Ipswich Summer School. Traveled to Japan in the fall. Resigned his teaching position at Pratt while abroad.
1904	Continued world tour, visiting China, India, Egypt, and Greece. Began work as a department head at Teachers College, Columbia University.
1906	Held the Ipswich Summer School of Art for the last time.
1908	The first of Dow's three solo exhibitions at the Montross Gallery, New York. He attended the International Art Congress in London and visited France.
1911	Solo exhibition at the Montross Gallery, New York. On a sabbatical from Columbia University Dow traveled to New Mexico, Arizona, and California.
1912	During his western travels Dow joined his former student Alvin Langdon Coburn to take photographs at the Grand Canyon.
1913	A solo exhibition at the Montross Gallery called *The Color of the Grand Canyon of Arizona*. Dow's titles for the paintings included: *Cosmic Cities; Silence; Red Temples;* and *Earth-waves*.
1914	Georgia O'Keeffe began two years of study with Dow at Teachers College.
1915	Won a bronze medal for his woodcuts at the Panama-Pacific International Exposition, San Francisco.
1917	Traveled to Oregon and Yellowstone National Park.
1919	Traveled to Grand Canyon.
1922	Died December 13, in New York. Los Angeles became the national center for Dow's teaching and philosophy when a group of his students established the Arthur Wesley Dow Association; their center of operations was the University of California, Southern Branch.
1923	The artist's widow sold their collection of Asian art and many works by Dow in New York. There were five auctions on three consecutive days; the grand total for the sales was $18,688.

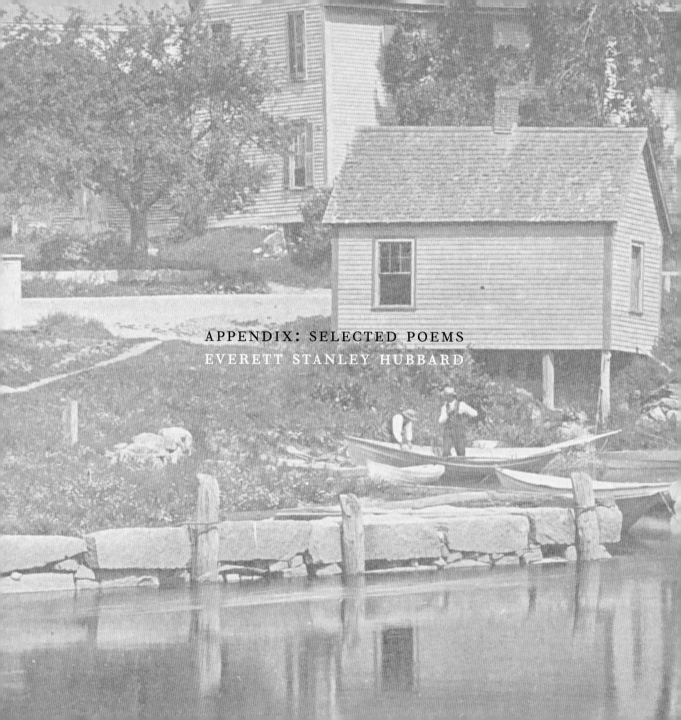

APPENDIX: SELECTED POEMS
EVERETT STANLEY HUBBARD

THE MARSH ISLAND LILY

In sylvan solitude the lily waves,
 The scarlet lily of marsh island birth.
She envies not the royal rose, nor craves
 The pride of earth.

For she is queen of nature's fugitives,
 All careless of the garden's brilliance blent.
Patrician of the wildwood here she lives,
 And is content.

To A. W. D.

The marshes lie in softly rippled white,
 The woodland wears a dusky violet hue,
 And Agamenticus a far thin mystic blue,
While over all is winter's keen crisp light;
And silence, save at intervals a slight
 And timid rustling of the grass and vines,
 The cawing of the crows among the Pines
And ax strokes in the Thicket to the right.
Like one who offers to an old-time friend,
 In other scenes, a sketch made hastily
Of native hills, this thought of home I send,
 And trust it dawns on you familiarly.
While groping idly where the shadows blend
 I found it face to wall in memory.

THE OLD STONE WALL

Where shadows rest, where summits shine,
 The wall dips low and curves and climbs,
A repetition in each line
 Like old immortal rhymes.

The bowlders rest among the reeds,
 The butterflies above them dance,
Through all the tangle of the weeds
 The shattered sunbeams glance.

The tansy waves, the mulleins nod,
 The succory's forgotten blue
Between the rocks and goldenrod
 Repeats the heaven's hue.

It is the squirrel's safe highway
 Where evermore the sparrow sings,
While on its stones the lichens gray
 Outlive a line of kings.

Detail of *The Town Landing*, from *Ipswich Days*.

Rain in May

Blossoms and young leaves gently rock and sleep
 Within the cradle of the dying breeze,
And silvery creeks along the meadows creep,
 Beyond the snowy crests of apple trees.

And like the first faint echoes of a flute,
 Is heard the whispered sweep and gush of rain,
While purple mists like bloom on tender fruit,
 Are clinging to the valleys and the plain.

Lowland Willows

I stopped to see the lowland willows shake
 And silver in the sun.
I stayed to watch those winds of morning make
A ruffled pattern on the little lake
 When day had just begun:

So long ago! How swift the seasons run!
 I wish I could go back by fern and brake—
With those fresh dreams when youth and life are one—
To see in silver over shadows dun
 The lowland willows shake.

Chickadee

From stifling scenes alone extant
 For artificial graces,
From fetters forged by social cant
 And hoary commonplaces,
I come to you who never knew
 Restraint of tie or tether,
Then sing to me, my chickadee,
 In the winter weather.

The snarl of trade and politics
 The daily scrap and battle,
The bosses' and wardheeler's tricks
 The curse of village tattle;
I flee it all to come to him
 Whose heart is as a feather,
So sing to me, my chickadee,
 In the winter weather.

Dropped in this wide white solitude,
 Your song comes as a leaven
To merge the spirit of my mood
 With grove and hill and heaven.
My soul untaught, your heart unbought,
 Are lives that lie together
Ho, sing to me, my chickadee,
 In the winter weather.

Published verse with first known publication
AFTER THE BATTLE (*New England Magazine*, 1900)
DANCE OF THE WILLOW-LEAVES (*The Century Magazine*, 1909)
HARRY MAIN (*Old Ipswich in Verse*, first series, 1898)
IPSWICH MARSHES (*By Salt Marshes*, 1908)
A JUNE HUMORIST (*The Outlook*, 1909)
MARSH GOLDENROD (*By Salt Marshes*, 1908)
THE MARSH ISLAND LILY (*By Salt Marshes*, 1908)
THE OLD STONE WALL (*By Salt Marshes*, 1908)
THE PINE (*The Lotos*, 1896)
RAIN IN MAY (*By Salt Marshes*, 1908)
A SONG FROM THE HILLS (a Christmas poem published as
a postcard by E. P. Dutton & Co., New York, c. 1909?)
TO A.W.D., sonnet (*By Salt Marshes*, 1908)
THE THREE SHIPS (*New England Magazine*, 1892)
THE THRUSH (*The Outlook*, 1909)

Unpublished manuscripts: signed, documented,
or in Hubbard's hand (Ipswich Historical Society)
BACK TO MIIDERA
BENEATH THE SNOW
THE BIRDS OF LEAMING
CHICKADEE
CLOUD LEAVES
THE HARP
TO THE SONGS OF OLD
TO THOSE OF CHEER
VOICES OF THE SNOW
UNTITLED [first line: 'Tis the last jug of cider]

Attributed works, unsigned,
set in type (Ipswich Historical Society)
BACK TO THE SWATH
THE CALL OF THE QUAIL
LOWLAND WILLOWS

Missing works (mentioned in Dow's letters to
Hubbard, 1909–10, Ipswich Historical Society)
APRIL AFTERNOON
AT EARLIEST DAWN
AUTUMN SONG
BLUE CLOUD
BLUE IPSWICH BAY
CASTLE HILL
DON'T FORGET
FAREWELL
HAWTHORNE'S DAISIES
HEPATICA
IN MARCH
IRIS
ISLES OF SHOALS
LAST DAISY
LONGINGS
LULLABY
THE MAY STORM
MORNING AFTER RAIN
NIGHTFALL
OLD IPSWICH HOUSES
PROMISE IN NOVEMBER
SONG
SONG OF THE BLUE GENTIAN
STREET SCENE
TO A LINNET
UNDERCURRENT
VOICE OF THE VEERY
WILLOW IN HOLLOW
THE THREE SAPPHICS

SELECTED BIBLIOGRAPHY
WORKS PUBLISHED SINCE DOW'S DEATH IN 1922

Acton, David. *Along Ipswich River: The Color Woodcuts of Arthur Wesley Dow*. New York: Hirschl & Adler Galleries, 1999.

Arthur Wesley Dow (1857–1922): His Art and His Influence, with contributions by Lauren Berkley, Richard J. Boyle, Nancy E. Green, Marilee Boyd Meyer, Barbara L. Michaels, and Frederick C. Moffatt. New York: Spanierman Gallery, 1999.

Boice, Susan Howard. *Professor Dow of Ipswich*. Ipswich, MA: Susan Howard Boice Publishing, 1999.

Chisolm, Lawrence W. *Fenollosa: The Far East and American Culture*. New Haven, CT: Yale University Press, 1963.

Cox, George, J. "The Horizon of A.W. Dow." *International Studio* 77 (June 1923), pp. 188–93.

Enyeart, James L. *Harmony of Reflected Light: The Photographs of Arthur Wesley Dow*. Santa Fe: Museum of New Mexico Press, 2001.

Finlay, Nancy. *Artists of the Book in Boston, 1890–1910*. Cambridge, MA: Harvard College Library, 1985.

Green, Nancy E. *Arthur Wesley Dow and His Influence*. Ithaca, NY: Herbert F. Johnson Museum of Art, Cornell University, 1990.

Green, Nancy E., and Jessie Poesch. *Arthur Wesley Dow and American Arts & Crafts*. New York: American Federation of Arts, 1999.

Havinga, Anne E. "Setting the Time of Day in Boston." In *F. Holland Day*, edited by Pam Roberts, pp. 29–38. Amsterdam: Van Gogh Museum; Zwolle: Waanders Publishers, 2000.

Johnson, Arthur Warren. *Arthur Wesley Dow: Historian, Artist, Teacher*. Ipswich, MA: Ipswich Historical Society, 1934.

Lancaster, Clay. "Synthesis: The Artistic Theory of Fenollosa and Dow." *Art Journal* 28 (Spring 1969), pp. 286–87.

Margolin, Victor. *American Poster Renaissance: The Great Age of Poster Design, 1890–1900*. New York: Watson-Guptill Publications, 1975.

Masheck, Joseph. "Dow's 'Way' to Modernity for Everybody." In Arthur Wesley Dow, *Composition: A Series of Exercises in Art Structure for the Use of Students And Teachers*. Reprint of the 13th edition (1913), pp. 1–61. Berkeley: University of California Press, 1997.

Meech, Julia, and Gabriel P. Weisberg. *Japonisme Comes to America: The Japanese Impact on the Graphic Arts, 1876–1925*. New York: Harry N. Abrams, 1990.

Meyer, Marilee Boyd, ed. *Inspiring Reform: Boston's Arts and Crafts Movement*. Wellesley, MA: Davis Museum and Cultural Center, Wellesley College, 1997.

Mock-Morgan, Mavera Elizabeth. *A Historical Study of the Theories and Methodology of Arthur Wesley Dow and Their Contribution to Teacher Training in Art Education* (Ph.D. diss., University of Maryland, 1976). Ann Arbor, MI: University Microfilms, 1985.

Moffatt, Frederick C. *Arthur Wesley Dow*. Washington, DC: Smithsonian Institution Press for the National Collection of Fine Arts, 1977.

Nute, Kevin. *Frank Lloyd Wright and Japan*. 1993. London and New York: Routledge, 2000.

Peterson, Christian A. "American Arts and Crafts: The Photograph Beautiful, 1895–1915." *History of Photography* 16 (Autumn 1992), pp. 189–234.

Price, Aimée Brown. "Puvis de Chavannes and America." In *Toward Modern Art: From Puvis de Chavannes to Matisse and Picasso*, edited by Serge Lemoine, pp. 197–209. New York: Rizzoli, 2002.

Sellin, David. "Ipswich Figures in a French Background." In *The Ipswich Painters at Home and Abroad: Dow, Kenyon, Mansfield, Richardson, Wendell*, pp. 4–16. Gloucester, MA: Cape Ann Historical Association, 1993.

Shand-Tucci, Douglass. *Boston Bohemia, 1881–1900*. Vol. 1, *Ralph Adams Cram: Life and Architecture*. Amherst, MA: University of Massachusetts Press, 1995.

Whitehill, Walter Muir. *Museum of Fine Arts, Boston: A Centennial History*. 2 vols. Cambridge, MA: Belknap Press, 1970.

ACKNOWLEDGMENTS
TREVOR FAIRBROTHER

This project could not have come about without the commitment and kindness of the staff of the Addison Gallery of American Art: I am most grateful to Susan Faxon for supervising each and every step so deftly and enthusiastically; to Brian Allen and Allison Kemmerer for their additional support; and to everyone at the museum who worked directly with me: Juliann McDonough, James Sousa, Leslie Maloney, and Frank Graham. Bill Anton did an outstanding job designing the book and presenting Arthur Wesley Dow's cyanotypes as they have never been seen before; and Joseph Newland was a fine and inspiring editor.

My research and writing benefited from the assistance of many people. I would like to single out a few individuals who made frequent contributions: Stephanie Gaskins, Joseph Goddu, Paula Grillo, Bonnie Hurd Smith, Tom Lang, Evelyn Lannon, and Susan Nelson. And there were many others who responded generously to my requests for help: David Acton, Christine Berry, Lorien Bianchi, Susan Howard Boice, Janice Chadbourne, Carl Chiarenza, Lorna Condon, Rosemary Cullen, Abbott Lowell Cummings, Kate Dalton, Susan Hill Dolan, James Enyeart, Lee-Anne Famolare, Patricia Fanning, Colleene Fesko, Dan Finamore, Jan Fontein, James Graffum, Nancy Green, Jonathan Harding, Lilace Hatayama, Anne Havinga, Christopher Hogan, Karen Keane, Anne Rose Kitagawa, Karen Kramer, Jim Luedke, Julia McCarthy, Constance McPhee, Christine Michelini, Frederick Moffatt, John Morehouse, Patrick Murphy, Stephen Nonack, Maureen O'Brien, Roy Pedersen, Marjorie Robie, William Sargent, Paul Schlotthauer, Wilma Slaight, Miriam Stewart, Rachel Stuhlman, Kimberly Tenney, Pat Tyler, Mike Ware, Mary Warnement, and Kristen Weiss.

I would not have had this opportunity to work on Dow were it not for John Moran. I am indebted to you John, and to Susan and Isaiah Moran, for your friendship. Finally, I remain so very thankful to John Kirk for all that he brings to my life.

Detail of *Billy Lord's—The Haunted House*, from *Ipswich Days*.

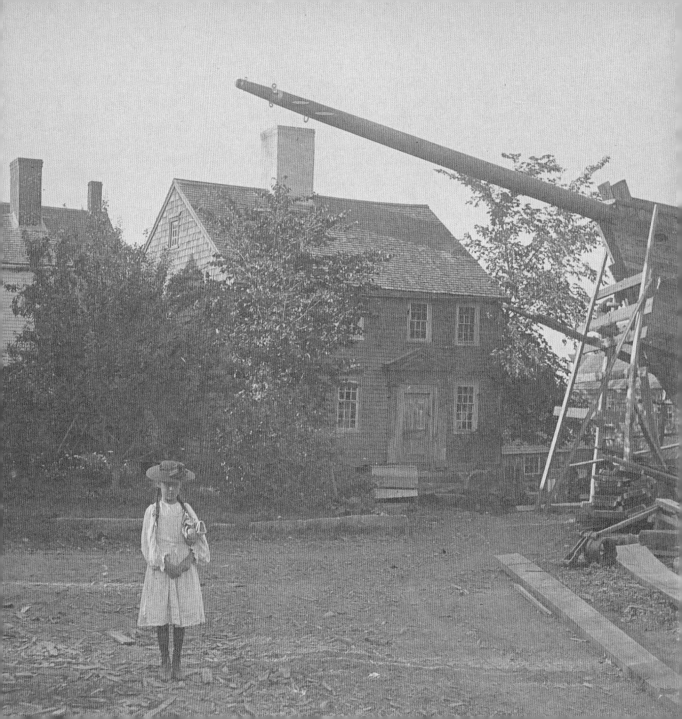

Detail of *Evening–Essex Shipyard*, from *Ipswich Days*.

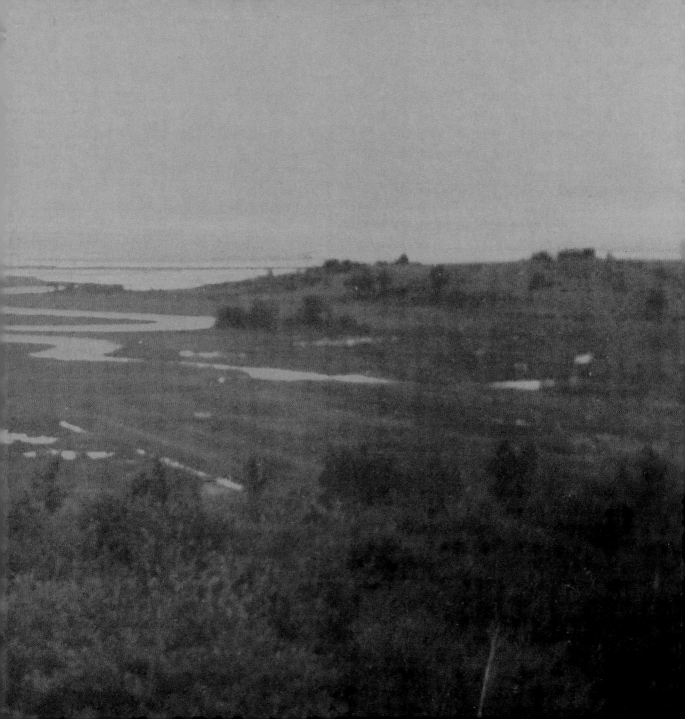

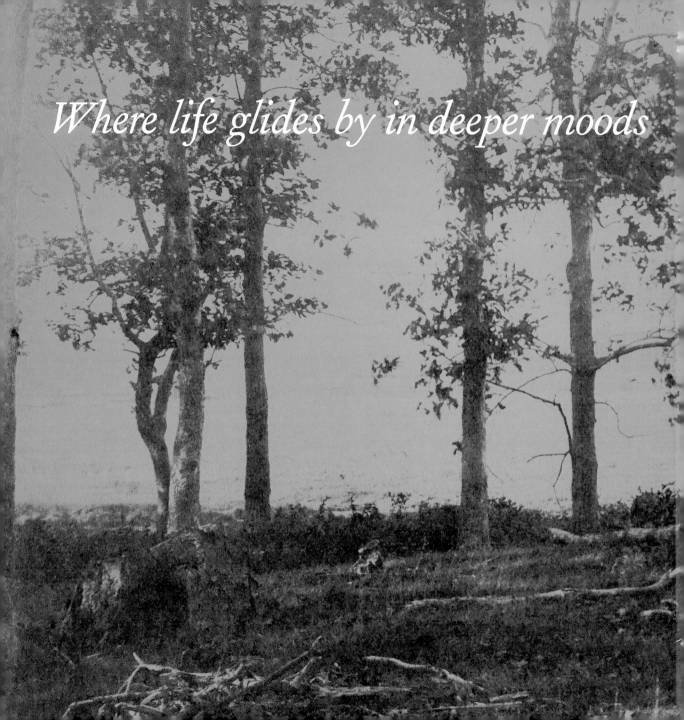

Where life glides by in deeper moods